SEX PISTOLS

THE END IS NEAR
2 5 . 1 2 . 7 7

KEVIN CUMMINS

KEVIN CUMMINS

ACC ART BOOKS

CAN YOU THINK
OF A BETTER WAY
TO SPEND CHRISTMAS?

JOHNNY ROTTEN

BANKHOUSE ENTERTAINMENTS

£1.75 presents ── £1.75

SEX PISTOLS

at **? ? ? ? ?**

Tel. Holmfirth 3939 Friday, 23rd December

Doors open at 7.00 pm

Please note: to prevent forgers, this ticket can only be purchased from
Pickwicks of Dewsbury or Ivanhoes, Huddersfield and will have required
signing for. In the event of any cancellation your money will be returned
less 25p administration fees.

[8]

BANKHOUSE ENTERTAINMENTS

£1.75 presents — £1.75

SEX PISTOLS

on CHRISTMAS DAY

at IVANHOES, Manchester Road, Huddersfield

Doors open at 7.00 p.m.

Please note: to prevent forgers, this ticket can only be purchased from Pickwicks, Dewsbury or Ivanhoes, Huddersfield and will have required signing for. In the event of any cancellation your money will be returned less 25p administation fees.

Venue at IVANHOES, Manchester Road
Huddersfield

Entrance Ticket No.

Nº 381

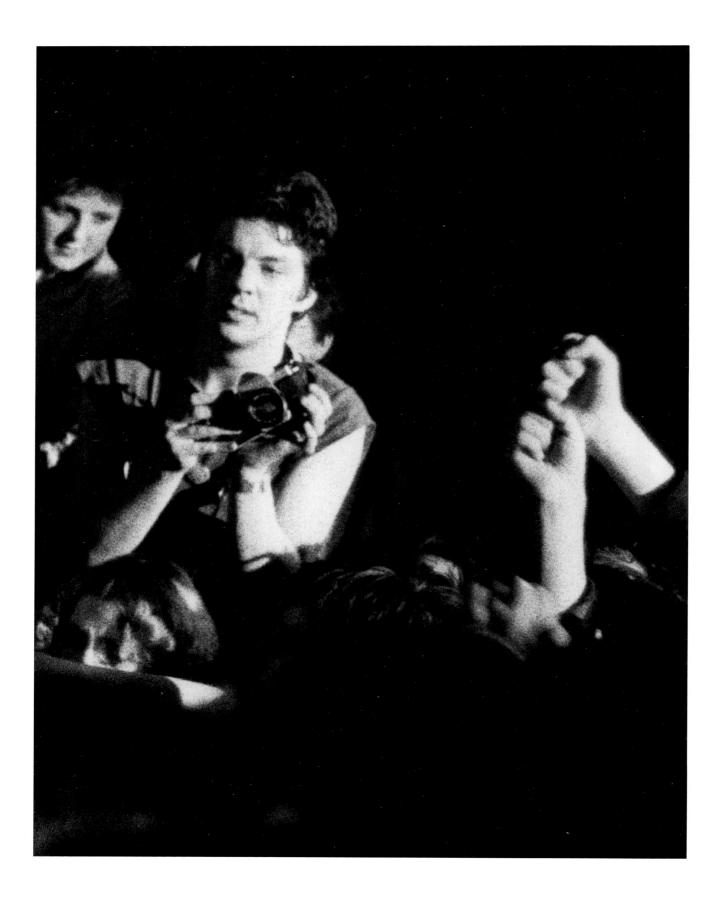

INTRODUCTION
KEVIN CUMMINS

On 4 June 1976, alongside a few curious onlookers, I went to see the Sex Pistols at the Lesser Free Trade Hall in Manchester. This has become one of the most seminal gigs in rock folklore. I didn't take a camera because I'd read how violent some of their earlier gigs had been. The audience of around 50 were suitably invigorated by the Pistols' energy and DIY ethic that evening. So much so, we all went on to form a band or start a record label or write or, as in my case, photograph musicians for a living.

It was the start of my career as a photographer for the *NME*; the self-proclaimed "World's Biggest Rock Weekly". I worked closely with Buzzcocks, who had brought the Sex Pistols to Manchester for this gig, one of their first outside London. I met the Pistols' manager, Malcolm McLaren, who was always supportive of Buzzcocks, and so by default McLaren was really supportive of me in helping me take my first steps in music photography, in this, my first year out of art school. He used to let me know when the Pistols were playing secret gigs and he'd always ensure I had a good spot to photograph them from – many Pistols gigs seemed to be clandestine events for the chosen few.

The fear and loathing of the Sex Pistols by local councils, fuelled by the pernicious and duplicitous UK media, was something McLaren was usually able to turn to his advantage. He was a smart manipulator and understood that the scarcer the gigs, the more frenzied the fans would be He loved playing games. The band meanwhile was typical of any band in that they just wanted to play live. They were frustrated by this circus Malcolm was constructing around them.

On Christmas Day 1977 at Ivanhoe's in Huddersfield, the Sex Pistols played what was to be their final UK concert, until their "return" in 1996. The gig at Ivanhoe's was part of a hastily arranged series of concerts made after discussions with several local councils who agreed to let the band play in their towns in December 1977.

This short tour was promoted as, "Never Mind the Bans; the Sex Pistols Will Play". Even then, several performances were cancelled at the last minute after dubious "police advice". The tour didn't take in Britain's major cities. It read more like a few chapters from JB Priestley's seminal 1934 travelogue *English Journey*. Indeed, Priestley visited Huddersfield, which he notes, "is not a handsome town, but yet is famous in these parts for the intelligence and independence of its citizens. Whether they really deserve this reputation, I have never been able to discover ..."

Over half the tickets for this Huddersfield gig were printed with no date or venue; just a series of question marks and a phone number in nearby Holmfirth. The grateful recipients had to ring on 23 December to find out when and where their £1.75 would take them to see Britain's most notorious band. McLaren rang to invite me to see the show. He told me that Julien Temple would be filming* and it was to be a benefit for striking firefighters' families in the afternoon, then they would play a regular concert in the evening.

The fact that the gig was on Christmas Day was quite a surprise. It was unheard of to go to a gig – never mind a Sex Pistols gig – on this most sacred of days. My parents were apoplectic with rage when I refused a glass of port with my Christmas pudding, then casually announced that I was off to nearby Huddersfield to see the anti-Christ (and pals) in concert. I didn't dare attempt to go for the whole day, unfortunately. I thought it was pushing it to leave the house at all. My father didn't speak to me for at least three weeks afterwards. The only reason he didn't change the locks was because the whole of Britain shut up shop on Christmas Day.

McLaren, like Factory Records boss Tony Wilson, was highly influenced by the Situationists. They both embraced the immediacy and subversiveness of samizdat material. Pamphlets, flyers, underground happenings, gigs were announced on the day via flyers placed in influential bars and bookshops. Only the knowing would know.

In the early '70s Jamie Reid, who was responsible for most of the Pistols' graphics, worked for the Suburban Press who printed *Leaving the 20th Century: The Incomplete Work of the Situationist International*. Reid also contributed some original illustrations for this first major translation. In fact, some of Reid's work from this Situationist book was reused for the Sex Pistols when he joined Glitterbest (the Pistols' management company). These manipulators of punk leaned heavily on the Situationists for their inspiration.

Another influence shared by both Wilson and McLaren was *A Clockwork Orange*, the 1962 Anthony Burgess novel, realised on film by Stanley Kubrick ten years later. Malcolm was fascinated by the way the film satirised the media's faux horror of every generation's youth culture.

The lead character in the novel, Alex (played by Malcolm McDowell in the movie), is motivated to subvert society and is violent just because he enjoys violence.

He is intelligent and has plenty to say – far more than his dim-witted gang members – but he chooses to use violence over reason. Later in the book, Alex is used by the government as a propaganda tool; an example of all that is wrong with society. The tabloids lapped it up of course. To me this is almost McLaren's template for his vision of the short history of the Pistols.

Lead singer Johnny Rotten's own influences were slightly more muddled. His public persona was a hybrid of picaresque villainy and social satire. He drew heavily on Vaudevillian characters from Music Hall and the Carry On films; all wonderful "great" British institutions. Another of John's influences was Pinkie, the teenage gang leader in Graham Greene's 1938 novel, *Brighton Pock*. A character who challenges or alienates everyone in his life. The product of a Catholic education, it's no surprise that Rotten read Greene. Devouring every work written by Graham Greene was de rigueur at my Catholic grammar school too.

Meanwhile, McLaren increasingly promoted the band as Dickensian street urchins playing out some Situationist fantasy that would ultimately implode. His handwritten flyer for the Huddersfield gig reproduced a George Cruikshank illustration of Dickensian urchins with text written by Malcolm, using a sharpened length of doweling dipped in ink and signed "Oliver Twist".

McLaren's cartoon vision of the band was at total odds with the way the actual band members saw themselves. Rotten was, and is, convinced that Malcolm wanted everything to unravel in a sensational manner, hence his arranging a US tour in early January of redneck bars / venues in the Deep South. However, I suspect that even McLaren, the arch-manipulator, didn't expect the unravelling to be so dramatically sensational as they left Heathrow on that January morning in 1978.

It was always exciting to be at a Pistols gig but this night at Ivanhoe's was doubly exciting. Malcolm's Christmas present to me was to invite me to shoot the show from the stage. I actually couldn't believe I was sharing a stage with my favourite live band at the time. It's very different to shoot from the stage. You get a real sense of what it's like to be in a band; to be adored. It also makes for great photographs because you can get the audience in shot and capture the energy, emotion and absolute buzz in the room. The gig passed in a blur. The band was immense that night. They were naturally in high spirits due to the party they'd had with the kids that afternoon. Even Sid occasionally broke into a smile. Everything came together. The audience was as important as the performance. We thought they'd go on to world domination. We had no idea that it was about to be their final curtain.

There is a photo of Temple in the foreground with his camera on pp 130/131.

Long shot date for Pistols

By
DENIS KILCOMMONS

THE Sex Pistols, Britain's most controversial punk rock band, are booked to appear in Huddersfield on Christmas Day.

In a stormy career the band have been sacked by a major recording company and had records banned by the BBC, including their version of God Save The Queen. They have won a court case over the title of their latest album.

The Huddersfield date will be one of less than a dozen appearances they will make in a mini-tour of the country after returning from concerts in Holland.

They are booked at Ivanhoe's which will have a 500 capacity for the night.

This is in keeping with the band's preference for playing small rock clubs rather than large concert halls.

Bill Wright, of Bankhouse Entertainments, who regularly books big name bands for Ivanhoe's Tuesday rock nights, said: "I know Christmas Day is a strange date but I am told this is the kind of crazy thing the Sex Pistols like to do."

John Jackson, of the Cowbell Agency in London, who handle the Sex Pistols, said: "I can't comment. Wait and see if the group play."

And his reluctance to confirm the booking is also in keeping with the way the band likes to appear at venues virtually unannounced.

Bill Wright added: "As far as I am concerned the booking is firm. Our regular Tuesday night attenders will be given priority over buying tickets for the Pistols."

The band are booked to play another Yorkshire date as well as Huddersfield, and should appear at Keighley's Knickers Club on December 19.

FOREWORD
PAUL MORLEY

THE SEX PISTOLS
WEREN'T MEANT
TO BE YET ANOTHER
MERE MUSIC
GROUP; DISRUPTING
MAINSTREAM
CULTURAL AND SOCIAL
SENSIBILITIES WAS
TOP OF MCLAREN'S
MANIFESTO

As if they were some kind of "ordinary" hard-working rock group, it was all going relatively normally for the Sex Pistols during 1976, when they played the majority of their English – and occasionally Welsh – gigs. They played small clubs, ballrooms, discos, colleges, polytechnics, the occasional prison, and plenty of ugly below-stairs London rock venues around Oxford Street and Soho. Their audiences were slowly growing, a few early adopters instantly identifying with their wit, irreverence and hostility, their somehow lethargic fury, copying their ragged anti-hippy short hair and the re-purposed clothes they wore – in some ways, the group was originally a living billboard for the Sex shop in Chelsea, London.

Unstoppable music paper reviews were either self-righteously dismissive of their apparent highly irregular and vulgar amateurism or entranced by their incendiary deconstruction of rock clichés and the poetically awkward, agitating words of slippery, scathing, possibly sickly lead singer Johnny Rotten. They'd signed to the very proper British record label EMI and there were some infatuated early fans who were influential enough to give them their first appearance on television – Tony Wilson, of Granada TV and later Factory Records, boldly booking them onto his *So It Goes* programme that adventurously mixed art, satire and music.

It was almost a conventional kind of career plan, considering their manager, foreman, salesman, chief prankster and enabler, and Sex owner, Malcolm McLaren had stolen the idea of a "totally obnoxious group" from some old acquaintances with connections to the vicious, sarcastic Situationist International, a mysterious, near-mythical French anarchist avant-garde movement (de)formed in 1957.

Gleefully playing the role of cultural terrorist/pantomime villain, he was committed to the Situationist policy of creating art

– and entertainment – out of "instances of transformed everyday life." The Sex Pistols weren't meant to be yet another mere music group; disrupting mainstream cultural and social sensibilities was top of his manifesto. Making money wasn't far down his list, but doing it like a pirate, like a conman conning the conmen in the miserably discriminatory music industry.

Then, on 1 December 1976, two days before the Anarchy In The UK package tour was set to take this new destabilising punk movement out of the small venues into the city halls and universities, the group were caught swearing on live television, sneeringly goaded by 53-year-old presenter Bill Grundy who was representing the straight, privileged conservative world they held in such contempt. (Grundy would be suspended for two weeks for "sloppy journalism.") You couldn't have planned it, and you certainly couldn't plan what happened next. The tabloids, always happy to induce moral panic, were "outraged" – the word "fuck" had only been heard on British television twice before the Pistols' Steve Jones casually lobbed two of them at Grundy – and they became an accidental part of the Sex Pistols' inflamed promotional campaign, hounding and harassing the group to destruction as much as they provided plenty of free, filth and fury advertising.

The Sex Pistols leapt overnight from minor cult fascination to the torrid centre of culture itself, where the jagged games McLaren and conceptualising comrades fancied playing with establishment power and mainstream media systems made more sense. Revolutionary theatre could now be played out where it belonged, in front of the masses. The revolution must be first for workers and peasants!

The first few dates of the end of year Anarchy tour were cancelled. The thought of this fucking circus, this criminal gang, was too much for some city councils and university chancellors, who banned the tour from entering their little realms fearing riots and worse; the bans, the group's tantalising enforced absence, the tabloid-stoked myths, McLaren's transgressive antics and the energised music paper hyperbole that snaked around their increasingly sensational name transformed their audience from hundreds to hundreds of thousands.

In June 1977, they were promoted to the top of the charts with the radically upside down anti-national anthem "God Save

THIS WAS THE MOST MEMORABLE OF CHRISTMAS PRESENTS, AN UNREPEATABLE MIX OF DANGER, DISORDER AND PURE DELIGHT

the Queen," aggressively challenging the entire elitist notion of royalty, whether The Queen of England or Rod Stewart. They provided a necessary alternative to the way the establishment would use the Queen's Silver Jubilee celebrations to distract people from political chaos, economic breakdown and social disintegration. If the population had been drugged by spectacular institutionally controlled images and ceremonies to ignore a country on the brink of collapse, the Sex Pistols suggested there could be different drugs, different rituals and, therefore, a different reality.

A few bold – or just indifferent – places let the Anarchy circus roll into town, turning ordinary venues into raucous fun palaces – Leeds, Manchester, Caerphilly, Cleethorpes, Plymouth – but British fans outside London would then have to wait eight months before they got another chance to see what had by that point become as much a part of British history as Churchill, the Royal Mail post boxes, Robin Hood, Sherlock Holmes, Shakespeare, the Tower of London, the Union Jack and, of course, one way or another, its sense of humour.

Operating as though illegally from mobile underground bunkers, the group were forced to wear masks and enter local towns anonymously, as bandits more than a band – during August 1977, they played Wolverhampton, Doncaster, Scarborough, Middlesborough and Penzance variously as the S.P.O.T.S. (Sex Pistols on tour secretly), Tax Exiles, Special Guest, Acne Rabble, The Hamsters and A Mystery Band of International Repute.

Their final UK dates – masks off – were in December 1977, the Never Mind the Bans tour, with the two final shows – one an afternoon show for kids – on Christmas Day in Huddersfield. Haphazard history appropriately ending up in a very off-centred English town, where you were more likely to find the nation's authentic energy and hear the voices of the unheard, far away from bossy, entitled London town.

For those who managed to sneak out of their houses on a day when more or less no-one was allowed to leave, unless to visit relatives, this was the most memorable of Christmas presents, an unrepeatable mix of danger, disorder and pure delight. Father Christmas really did exist! On the side of angels with dirty faces. . .

Kevin Cummins was there, with camera, wickedly escaping another family Christmas and the Queen's Speech to the

shock/horror of his parents. He was used to following the uncanny, vilified everyday life of the Pistols and other punk groups as part war photographer, part show business photographer, part social documentarian. In a way, as a performer himself; the witnessing of astonishing events as a kind of performance.

His photographs where this performance is made permanent are not only of the Sex Pistols in libertine action opening up a new kind of space. They are also of an audience listening – to urgent, urging messages, to a charged combination of exhaustion and exhilaration – and of an audience being listened to. This was art in action, and they were part of it, living in the deep, convulsive moment, the dispossessed temporarily seizing control over their own lives.

By the second week of January 1978, playing in San Francisco, a few long days after Huddersfield, the Sex Pistols were swallowed up by the moronic inferno of America, Johnny Rotten getting the last word, delivering his famous punchline, "Ever get the feeling you've been cheated?" There were no plans in this revolution for a retreat. Once it was all over, there were many, unused to such dangerously seductive, delinquent outsiders, who breathed a huge sigh of relief and closed their doors again. Possibly one consequence of very vocal counter-culture ruffians getting all this attention for 18 months or so, starring in the next episode continuing the insanity of British history: Prime Minister Margaret Thatcher.

But that's another story.

THIS WAS ART IN ACTION, AND THE AUDIENCE WERE PART OF IT, LIVING IN THE DEEP, CONVULSIVE MOMENT

Writer and broadcaster Paul Morley grew up in Stockport and wrote for the NME between 1976 and 1984. A founder member of Art of Noise, he has written books about suicide, Joy Division, the Bakerloo Line, the history of pop, the North of England, Michael Jackson and David Bowie. He collaborated with Grace Jones on her autobiography I'll Never Write My Memoirs and his latest book is a biography of Anthony H. Wilson.

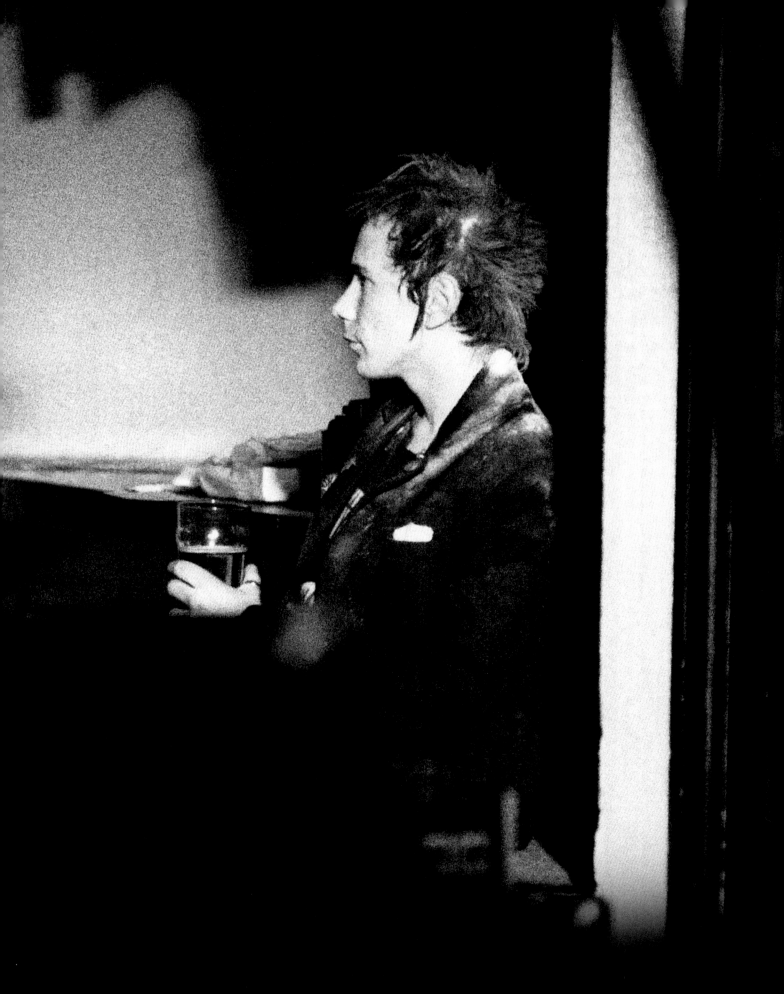

MEIN FREUND IST MEIN,
– UND ICH BIN DEIN,–
DIE LIEBE SOLL NICHTS SCHEIDEN.
ICH WILL MIT DIR
– DU SOLLSAT MIT MIR –
IM HIMMELS ROSEN WEIDEN,
DA FREUDE DIE FÜLLE,
DA WONNE WIRD SEIN

MY FRIEND IS MINE,
– AND I AM YOURS, –
LOVE WILL NEVER PART US.
I WILL WITH YOU
– YOU WILL WITH ME –
GRAZE AMONG HEAVEN'S ROSES,
WHERE COMPLETE PLEASURE
AND DELIGHT WILL BE

Bach's Cantata #140: "Wachet auf, ruft uns die Stimme"

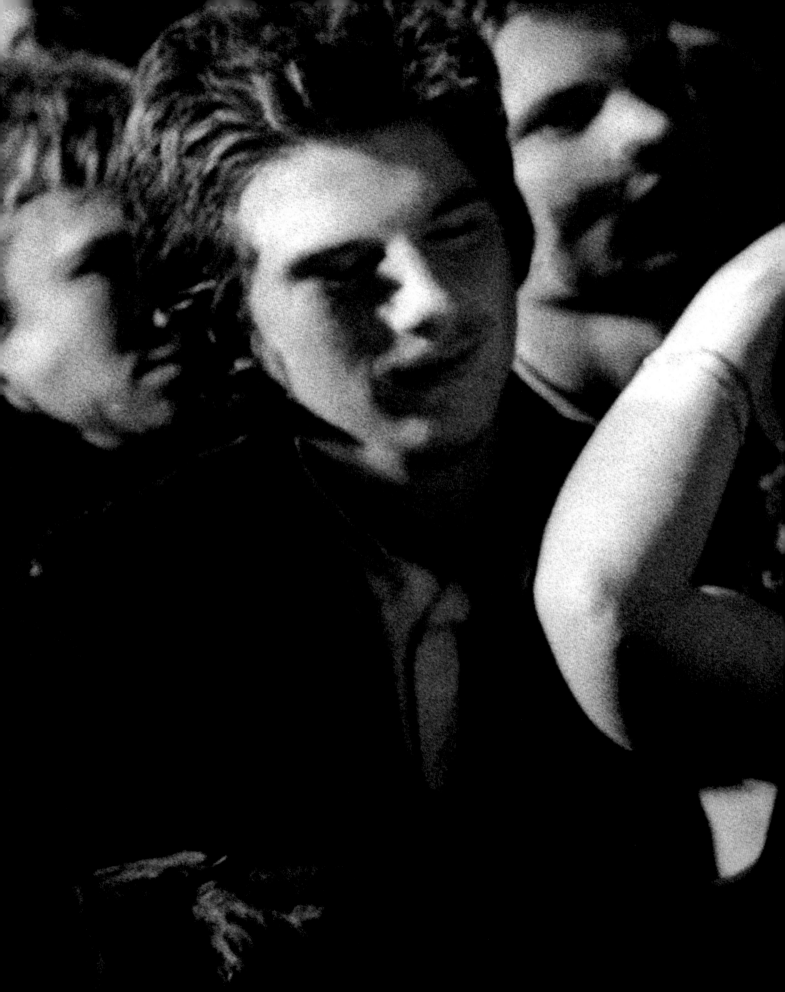

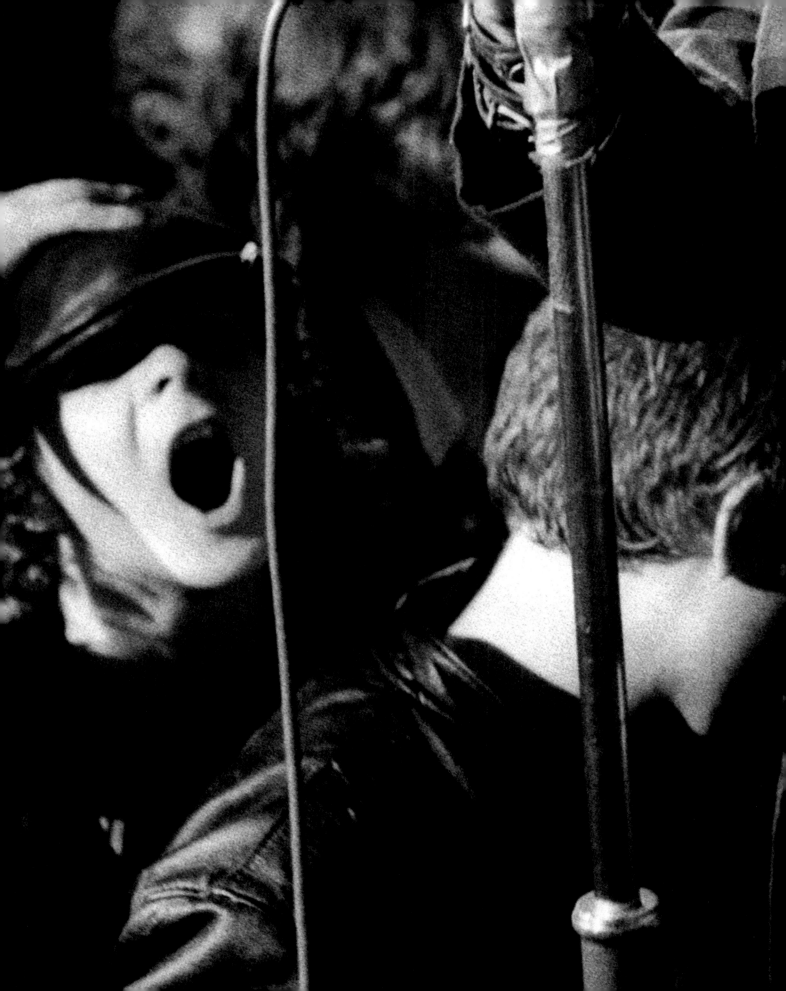

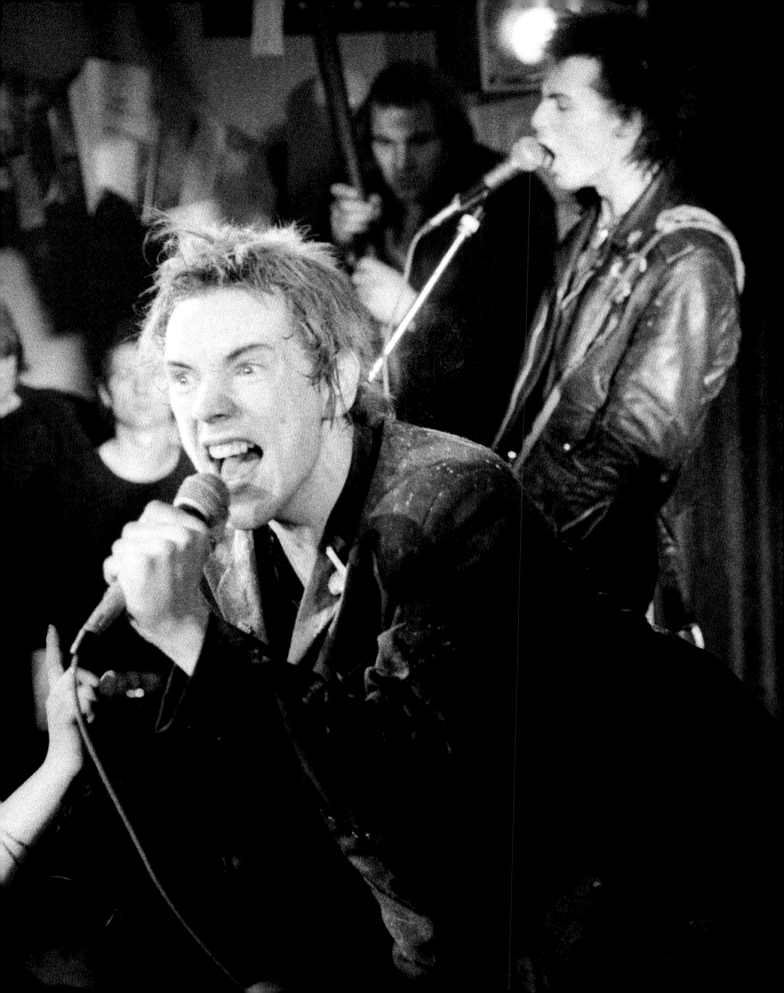

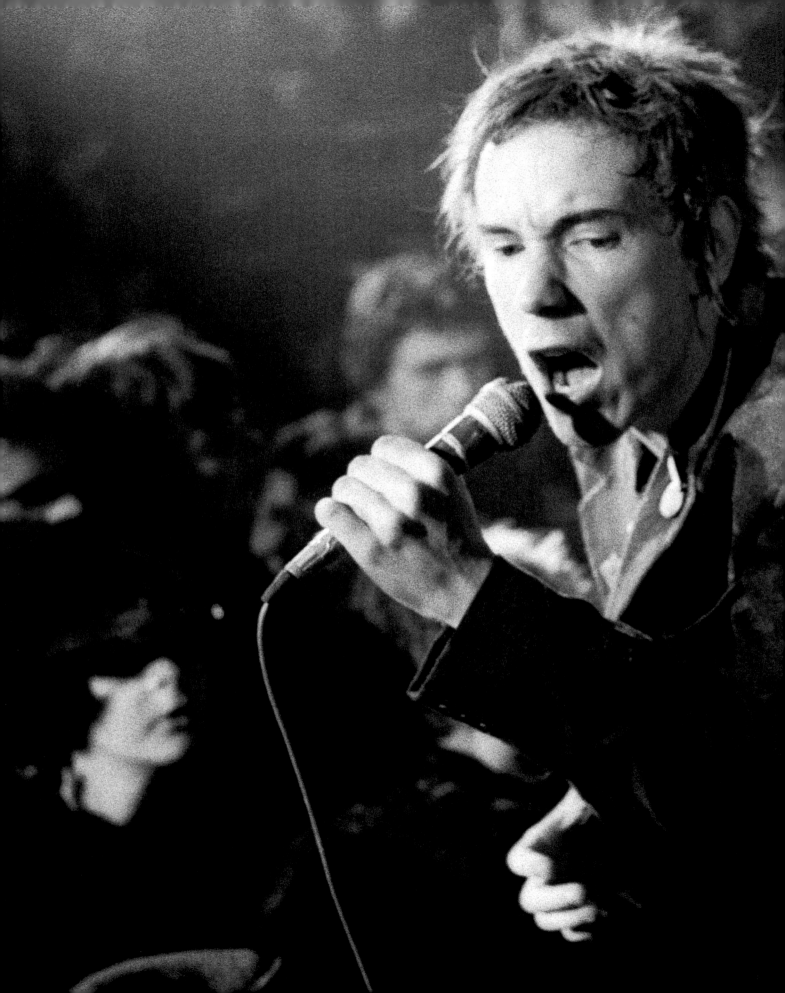

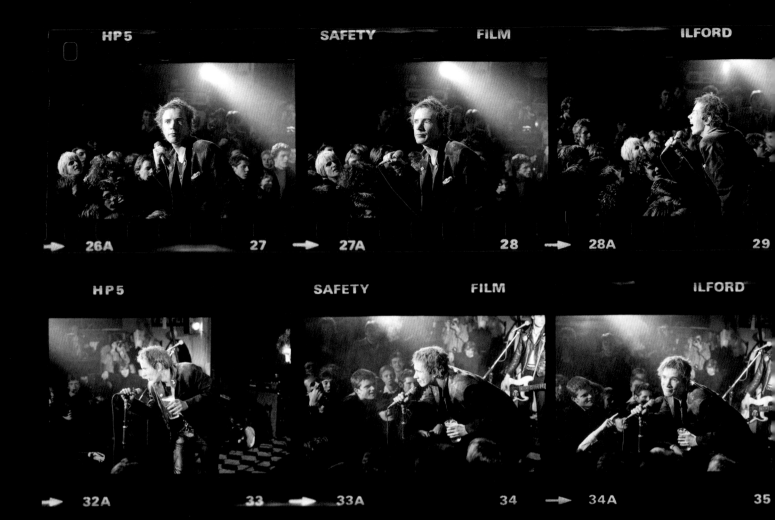

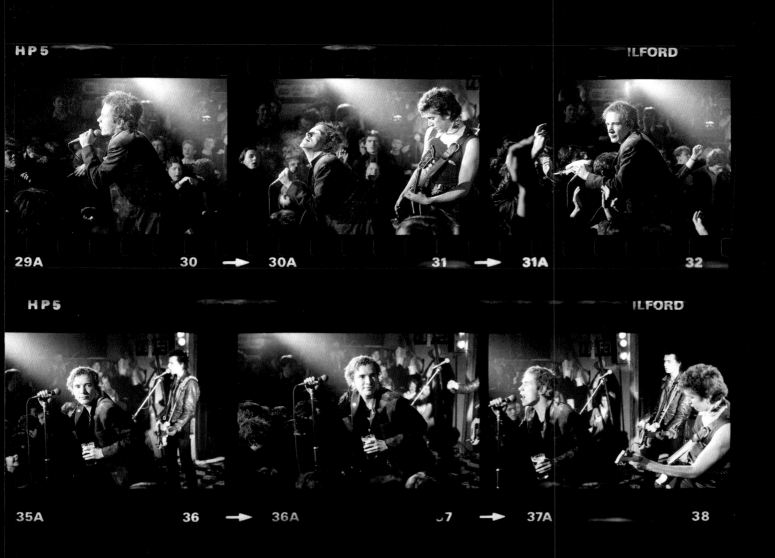

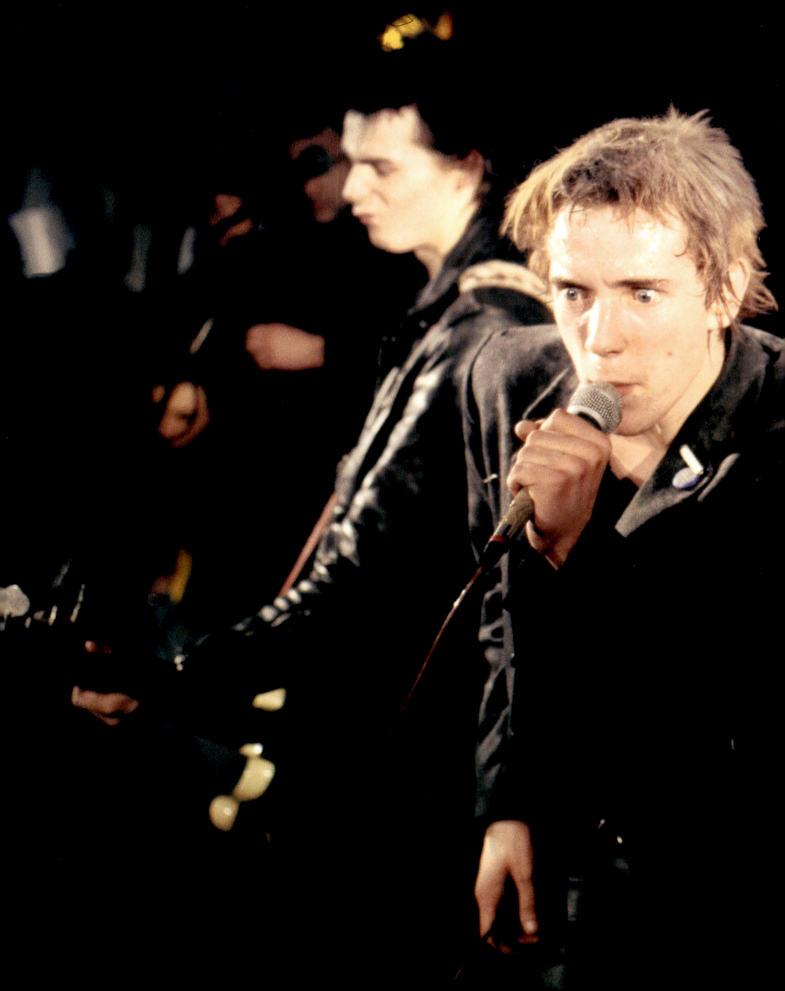

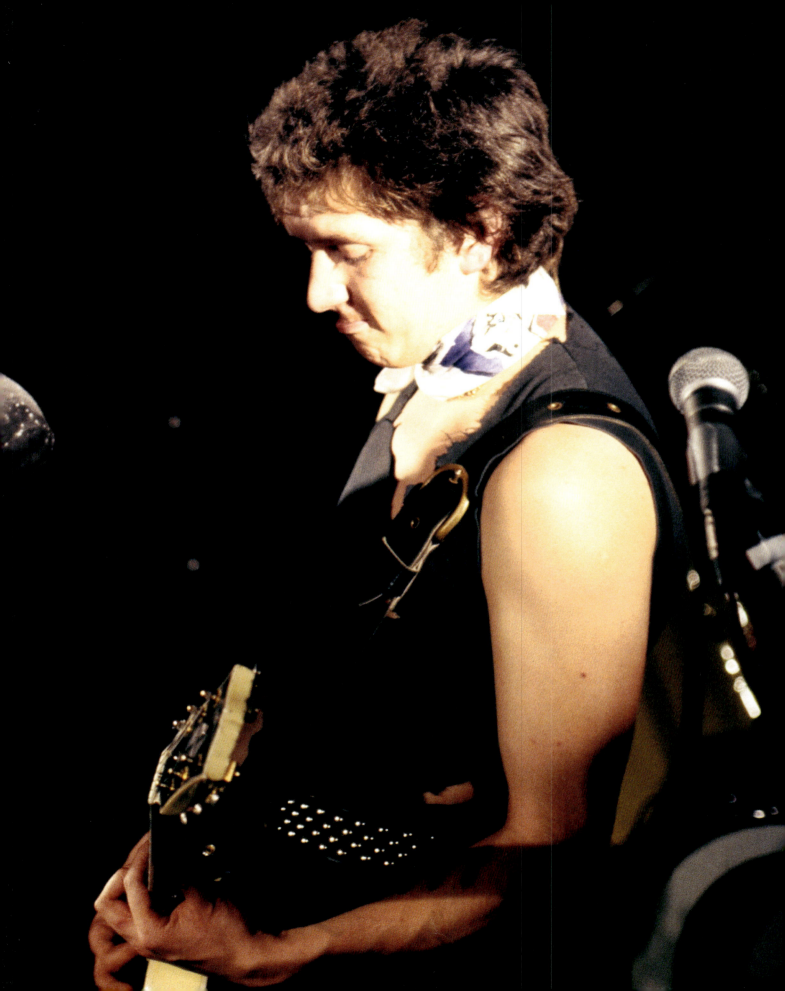

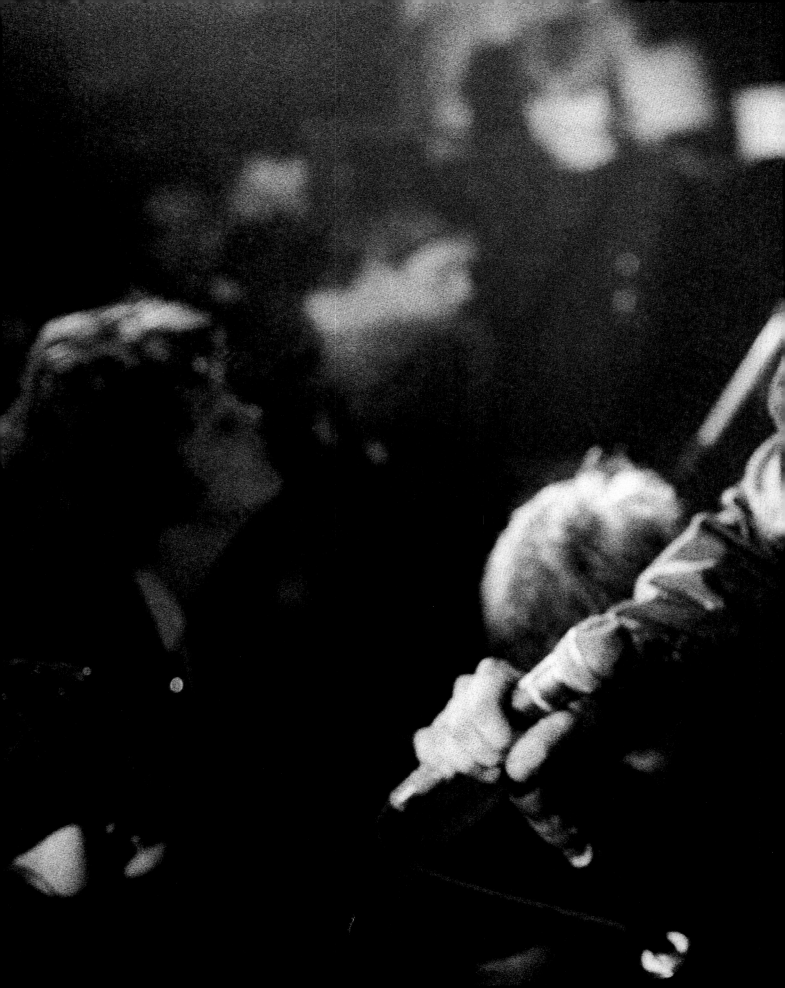

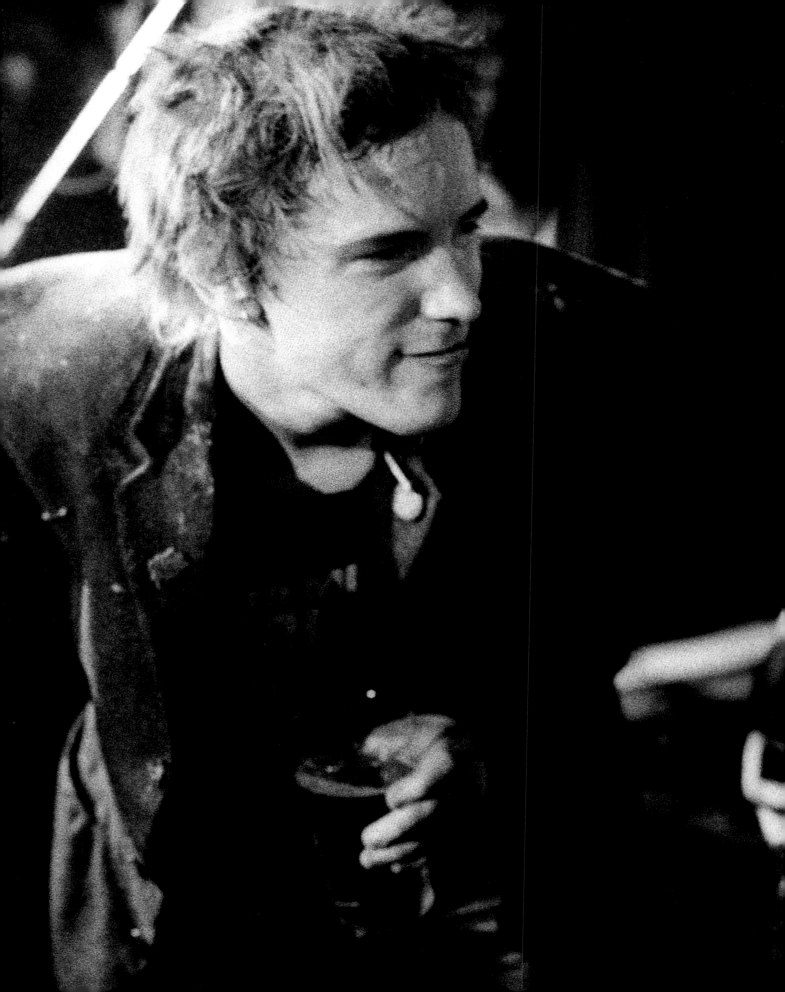

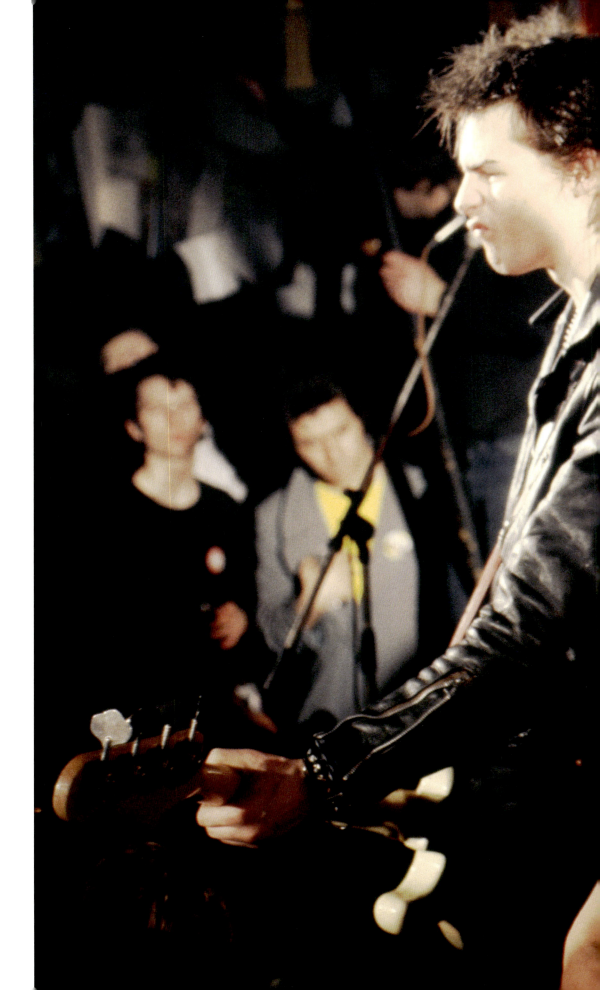

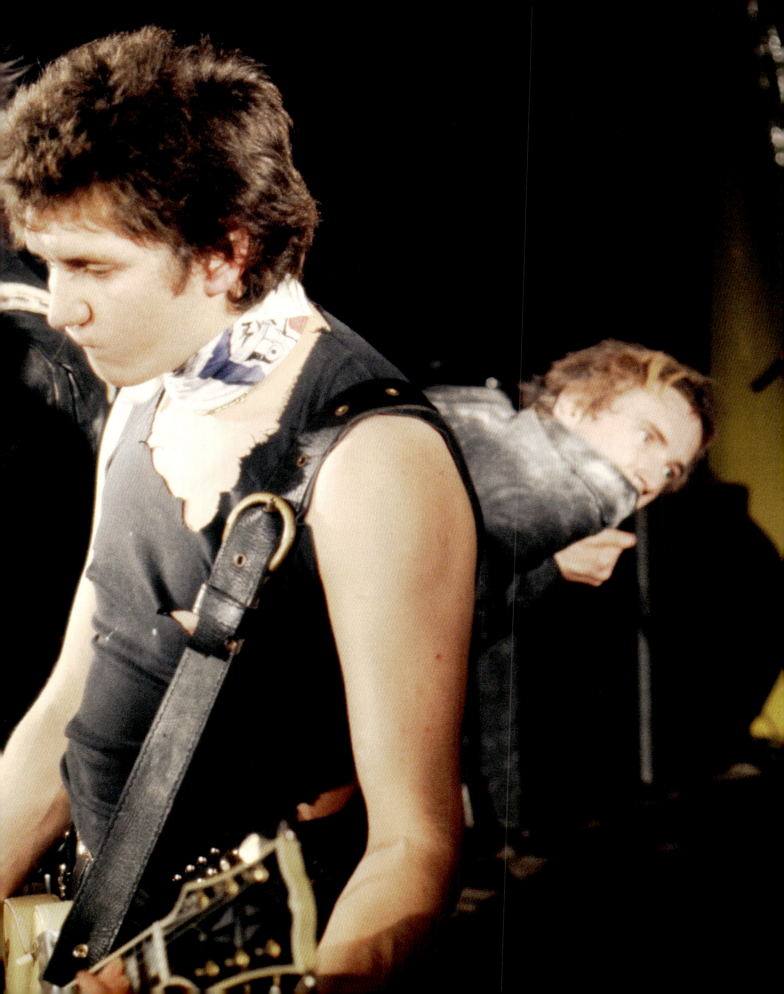

CHRISTMAS IS
MY WORST TIME
OF THE YEAR.
I'D GET SOME
SHIT TOY AND
MY MUM AND
DAD WOULD
LEAVE ME
ON MY OWN
AND GO TO
THE PUB

STEVE JONES

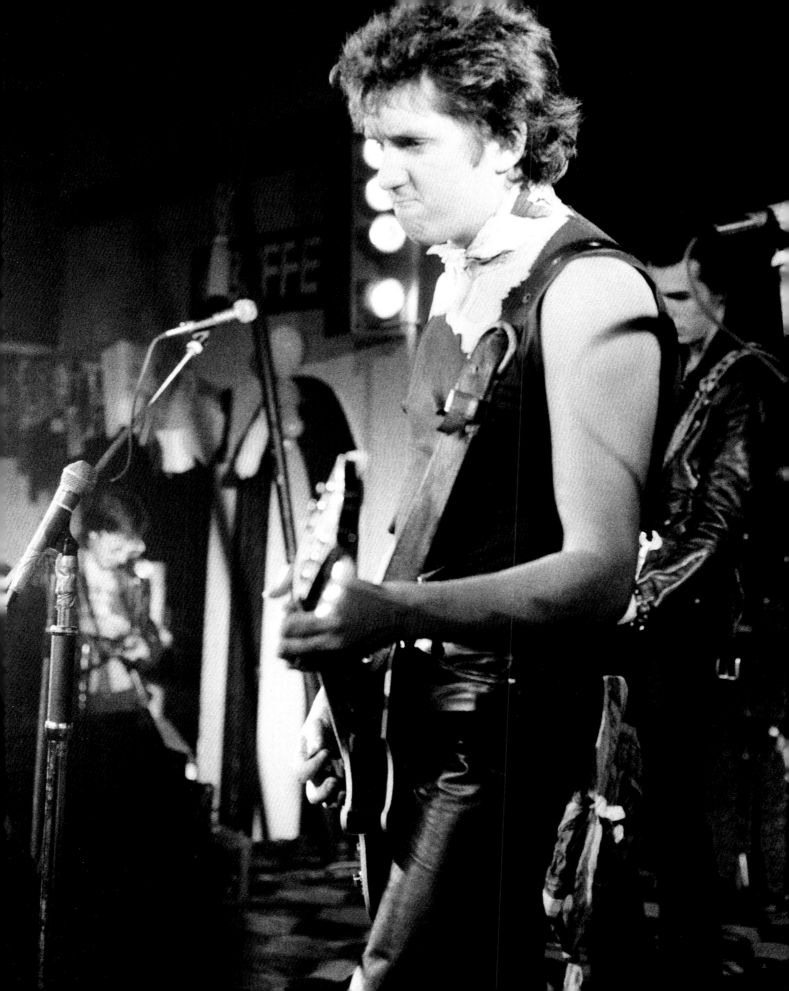

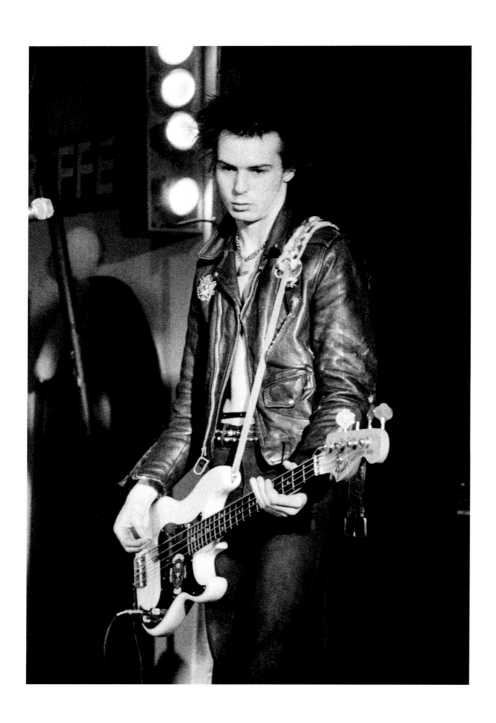

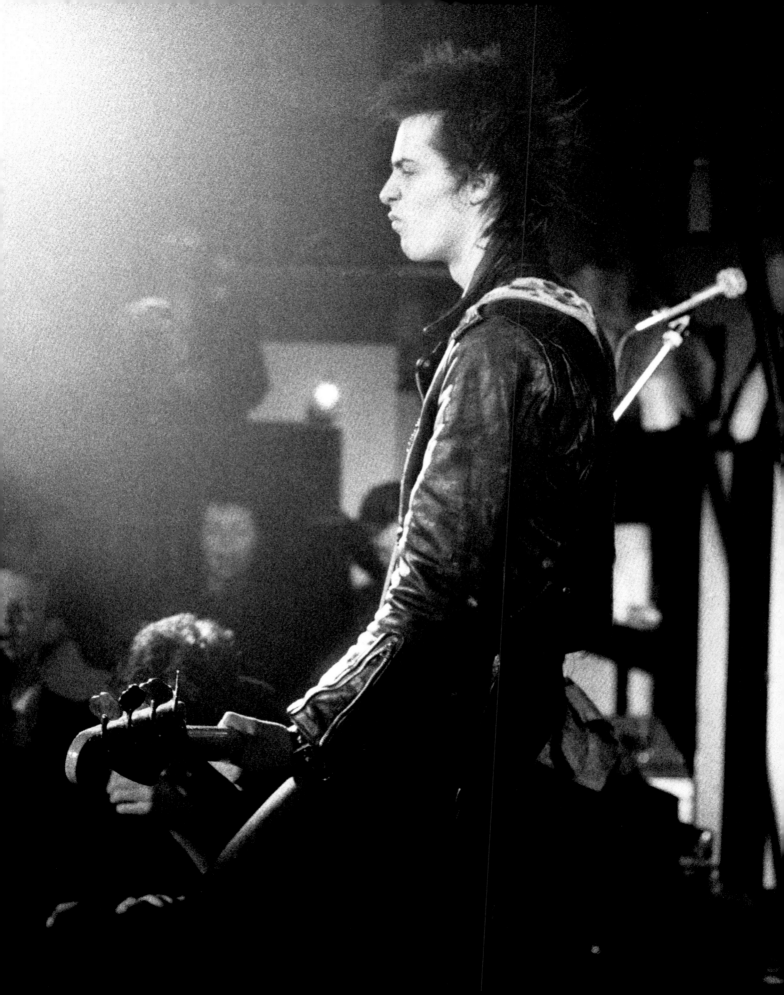

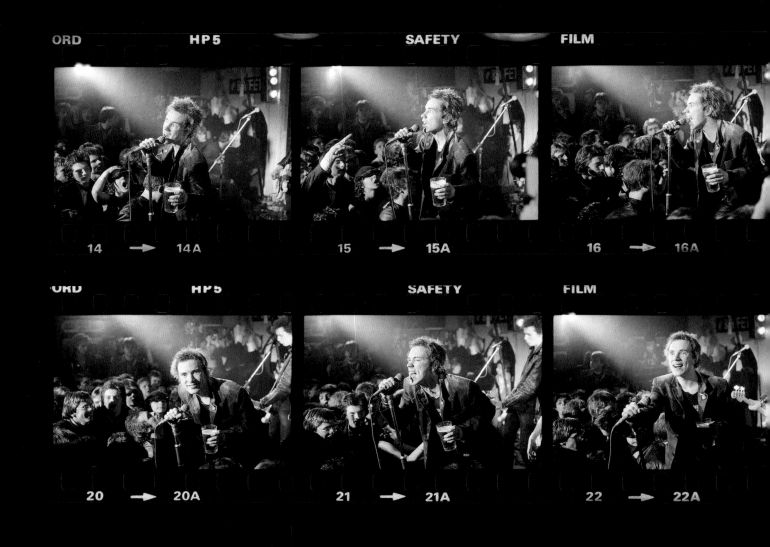

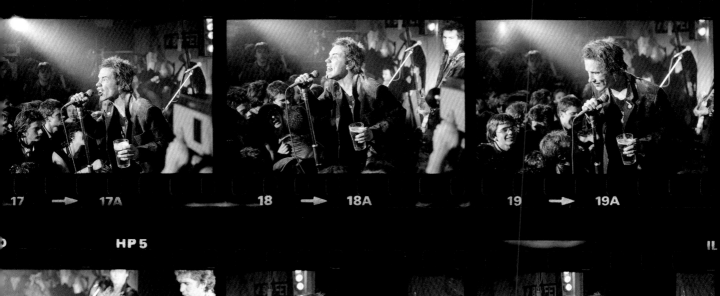

17 → 17A 18 → 18A 19 → 19A

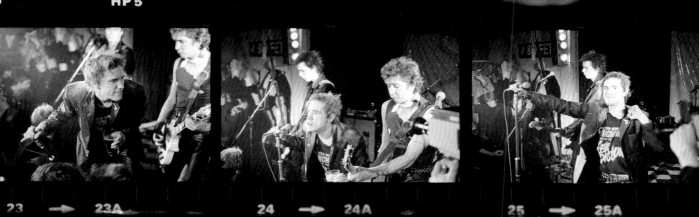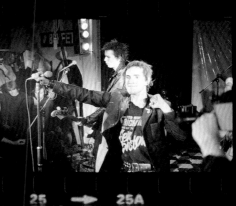

23 → 23A 24 → 24A 25 → 25A

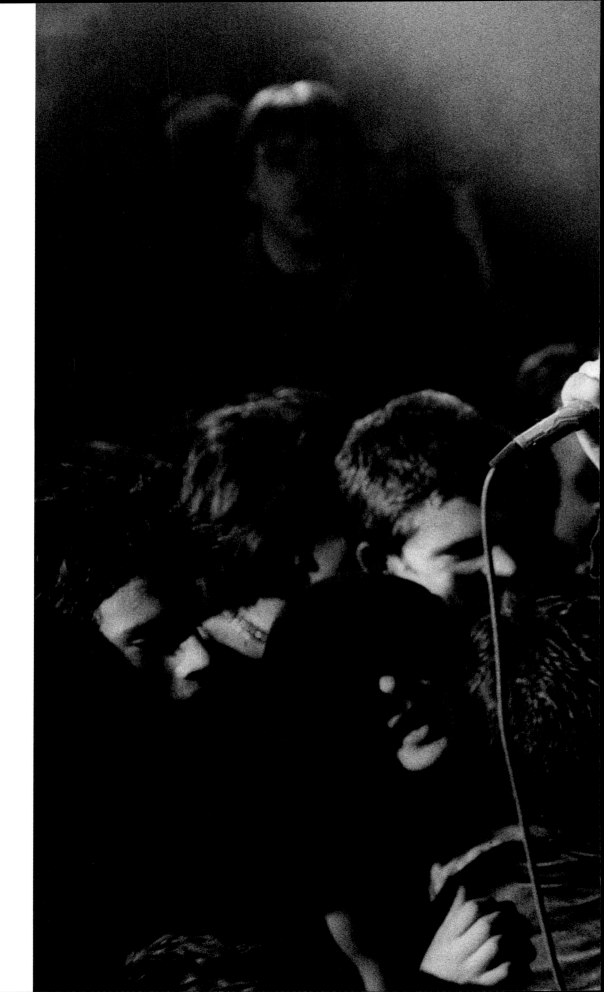

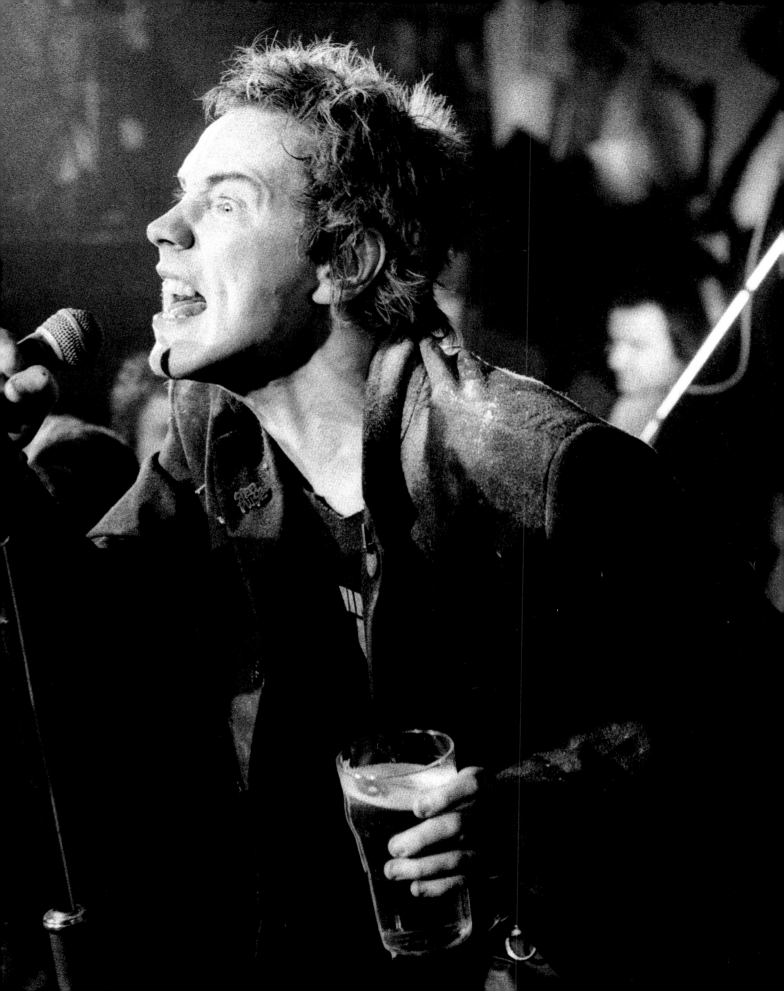

ILFORD

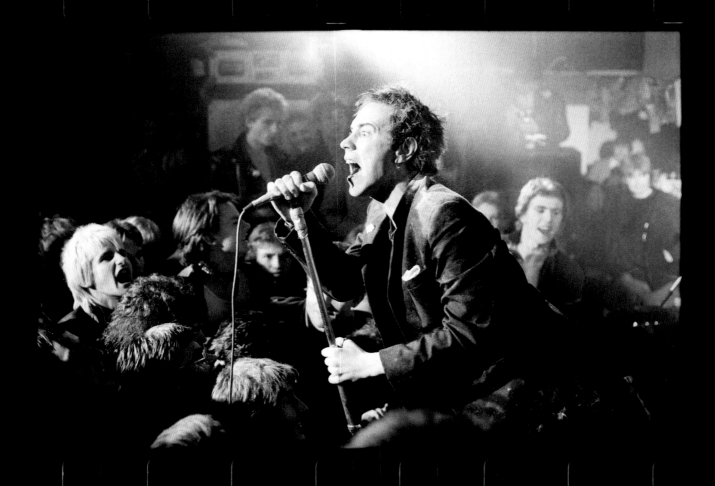

22A 23

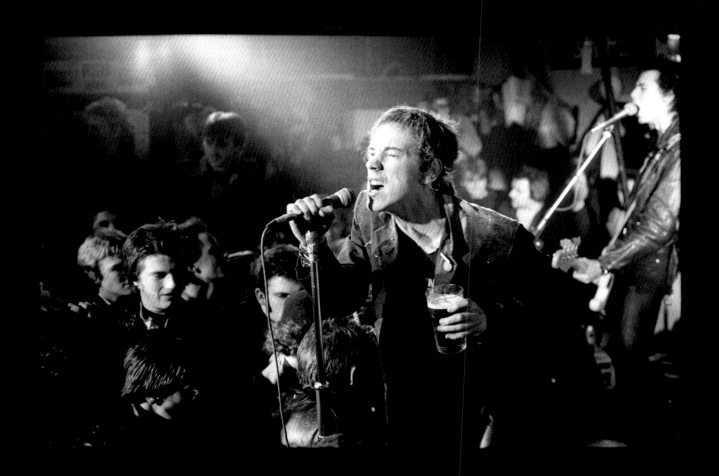

DRD HP5

8 → 8A

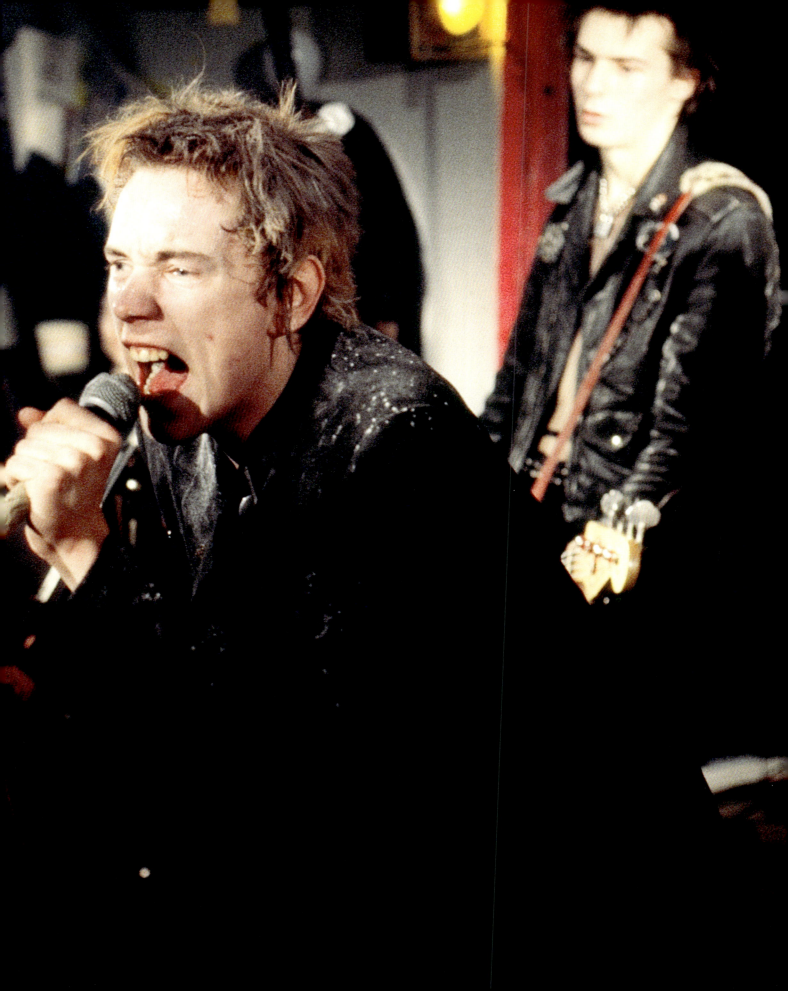

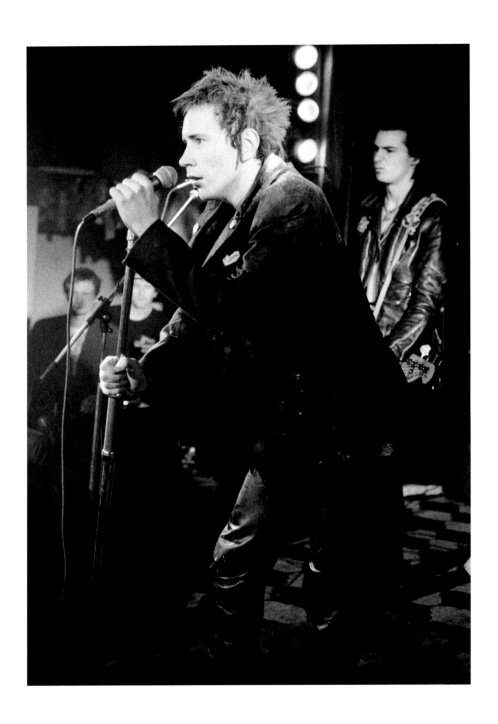

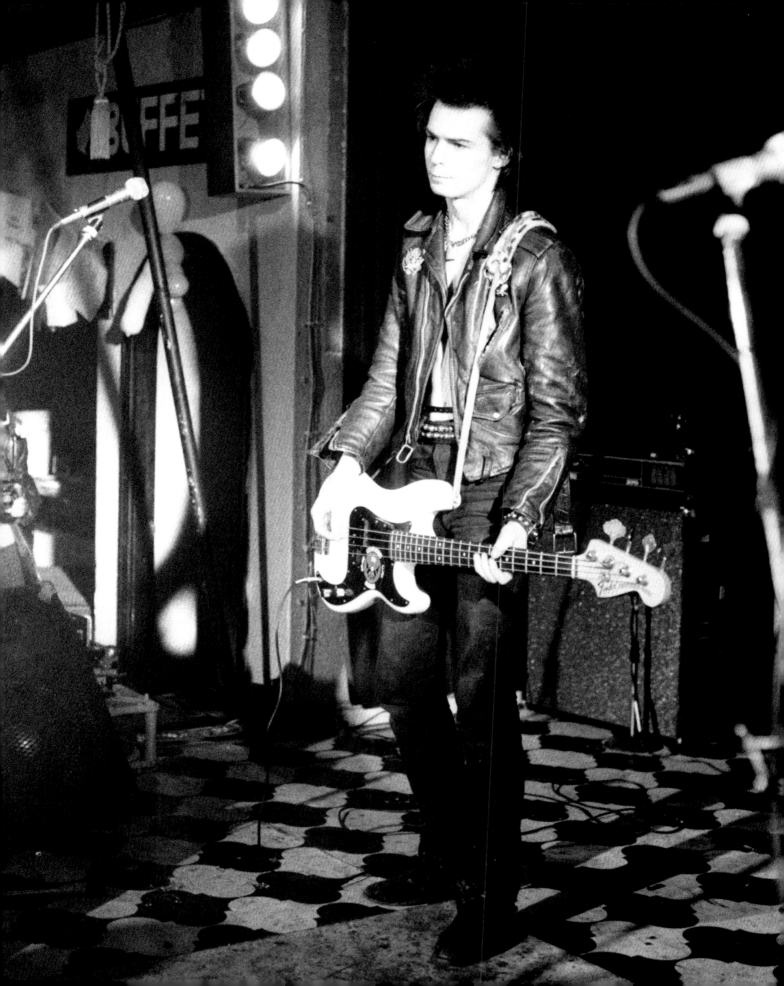

JUST THINK OF
HUDDERSFIELD.
THAT'S CHRISTMAS
ENOUGH

JOHNNY ROTTEN

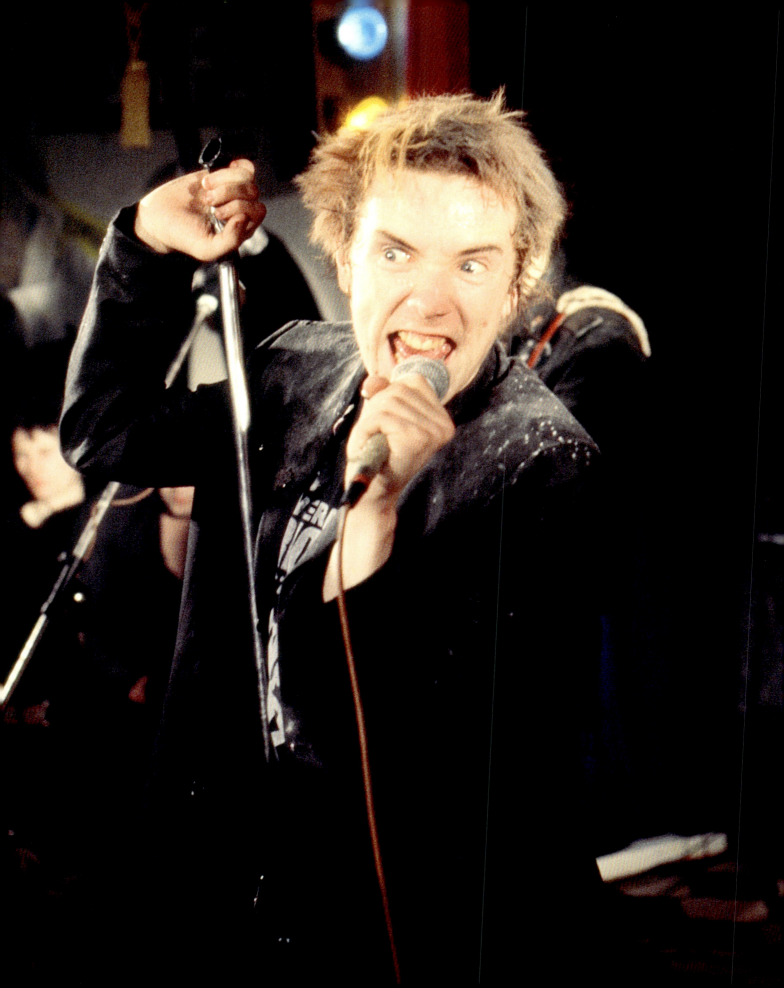

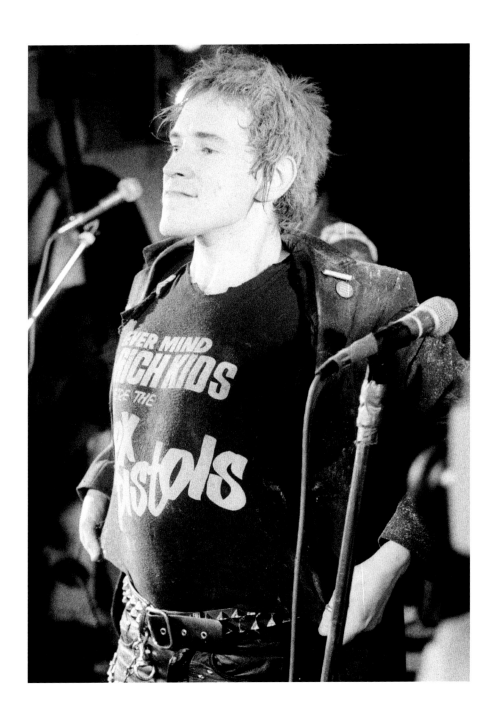

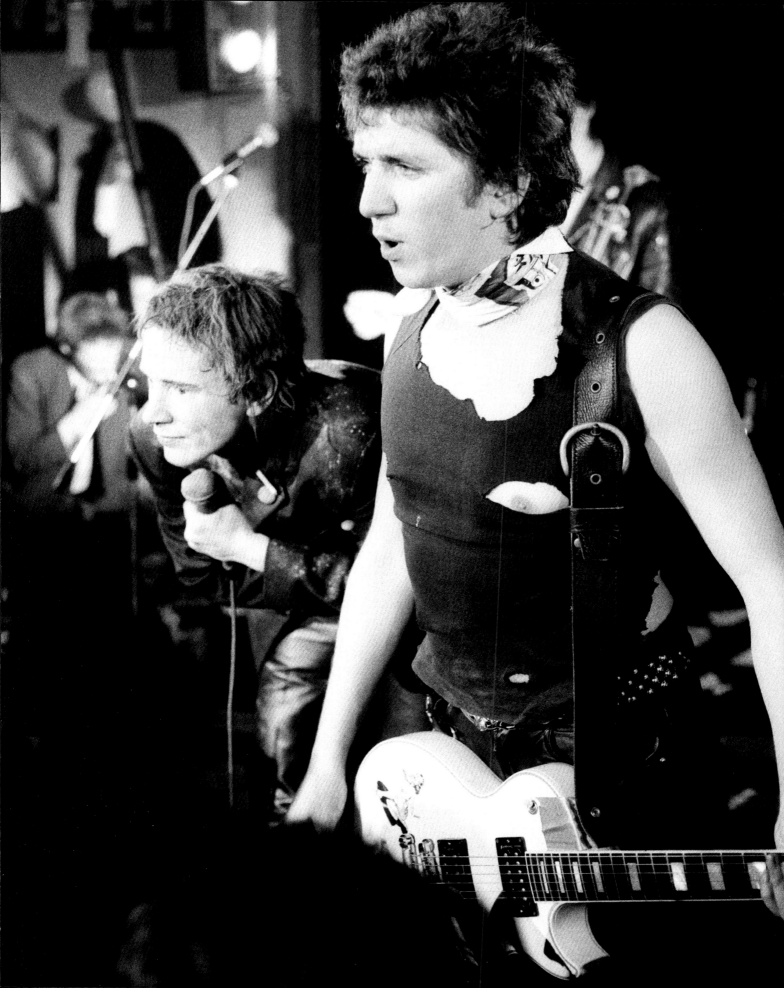

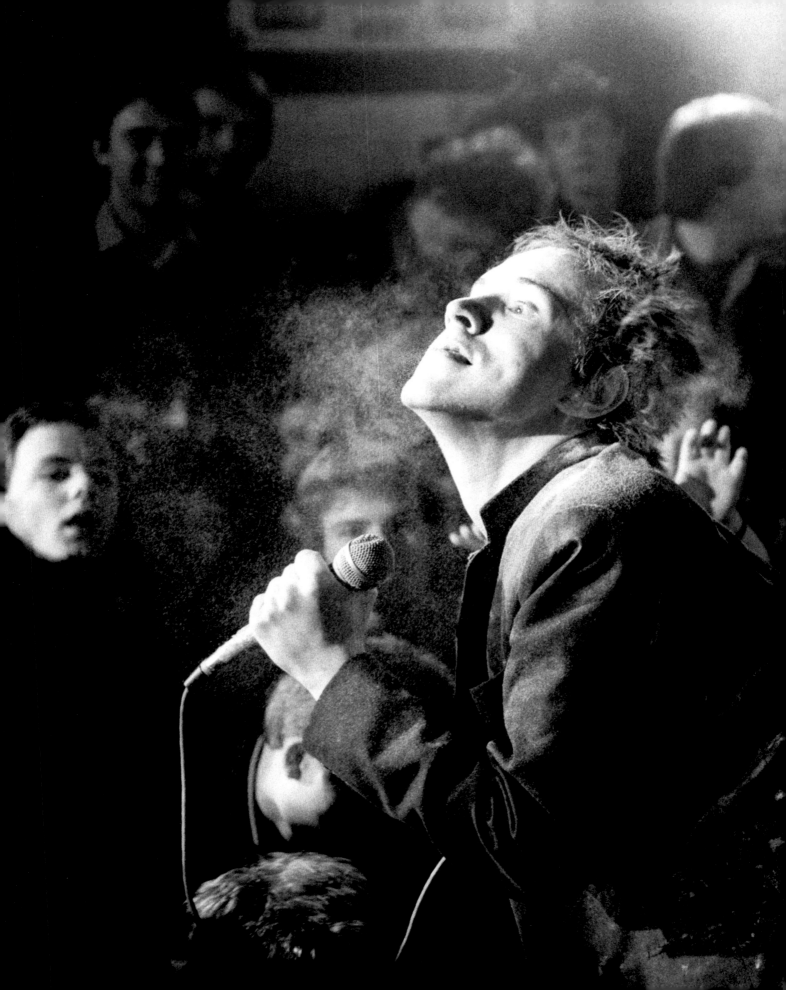

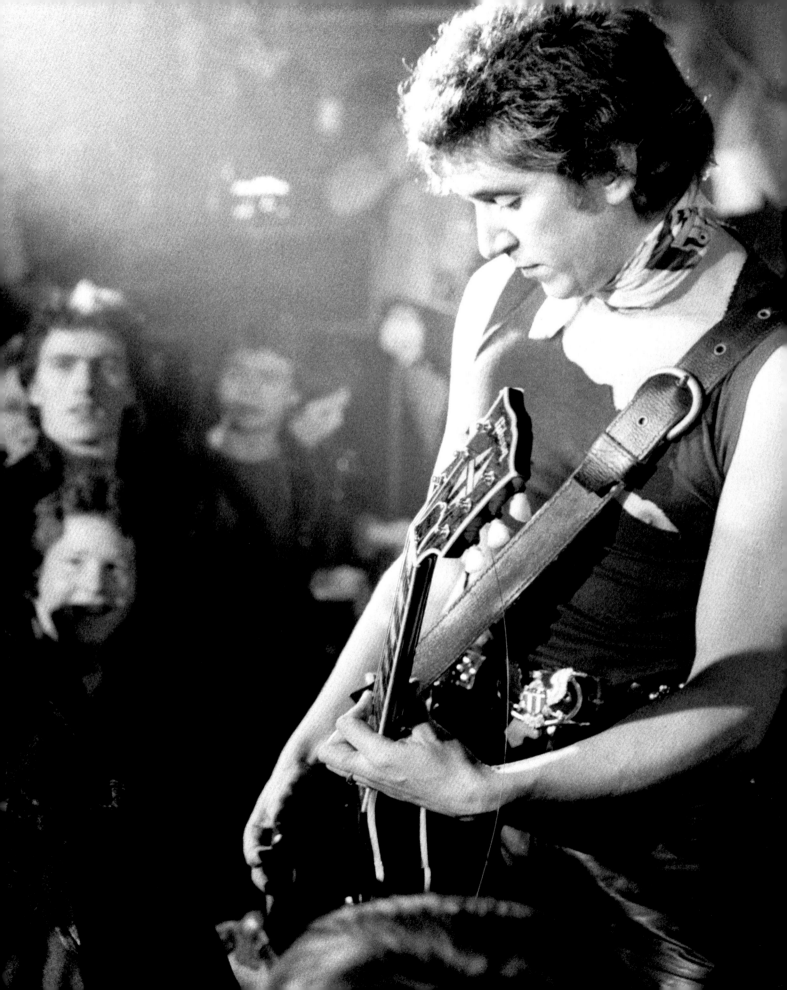

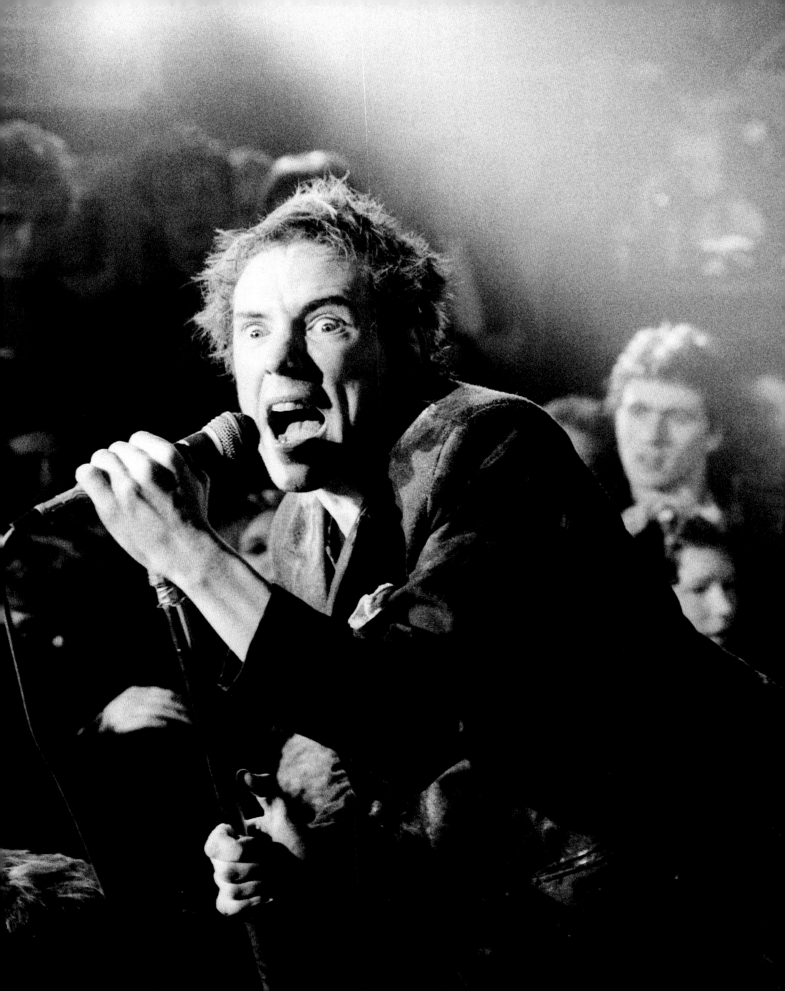

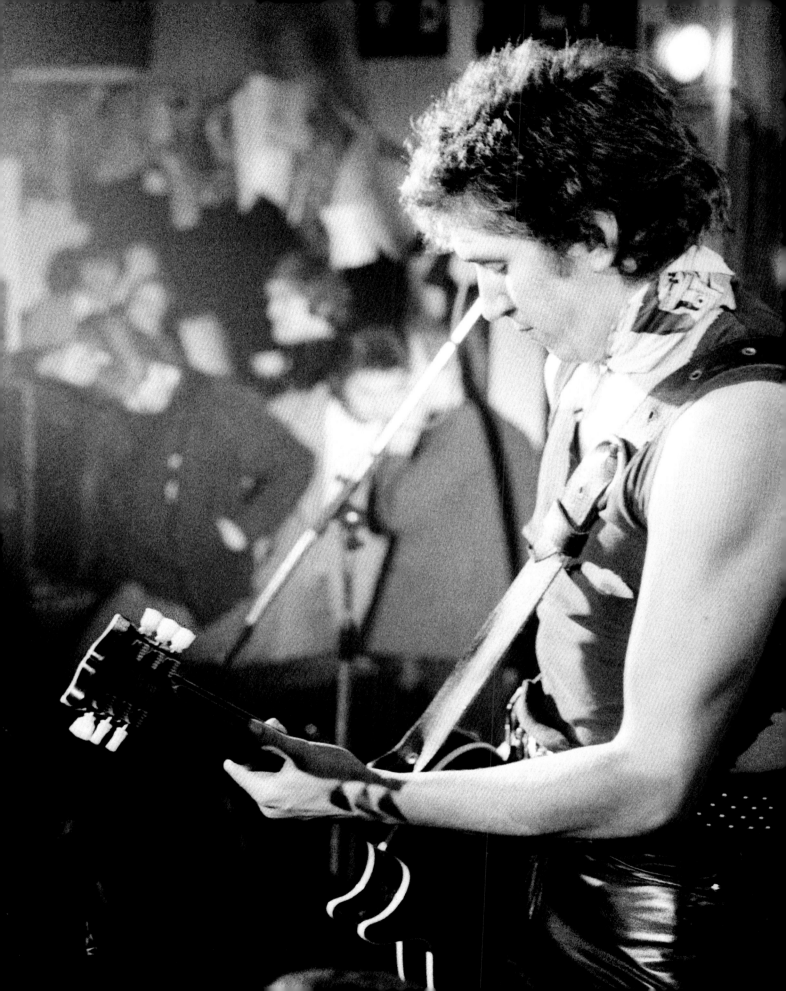

I DIDN'T THINK
[THE PISTOLS]
WAS GOING TO
BE OVER THREE
WEEKS LATER

STEVE JONES

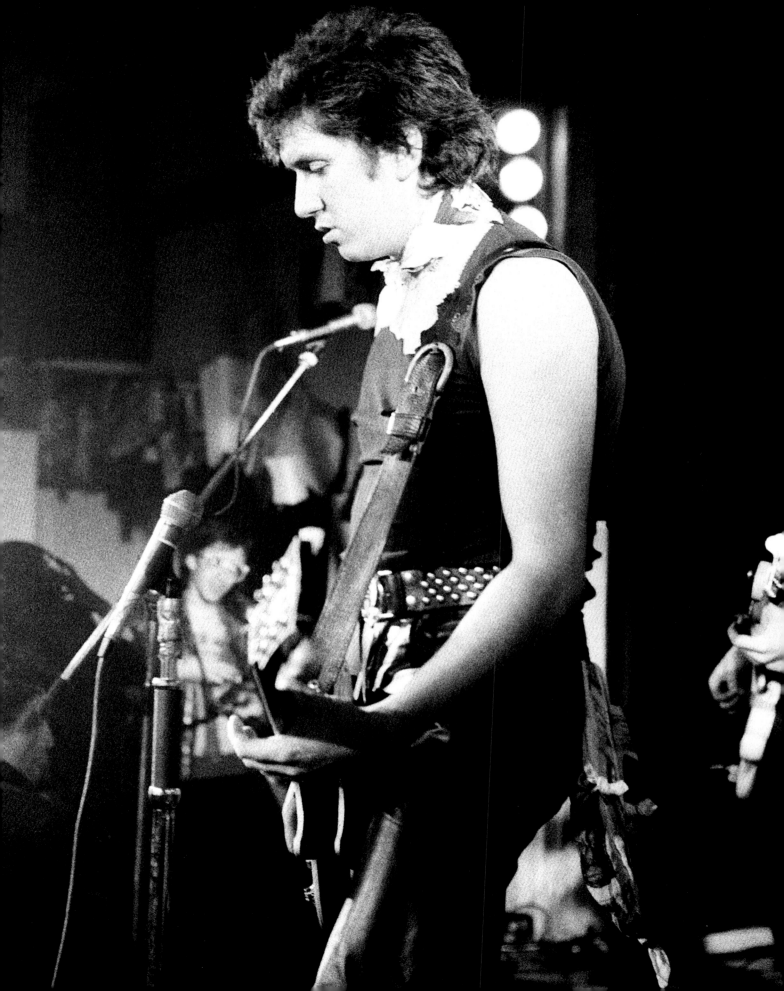

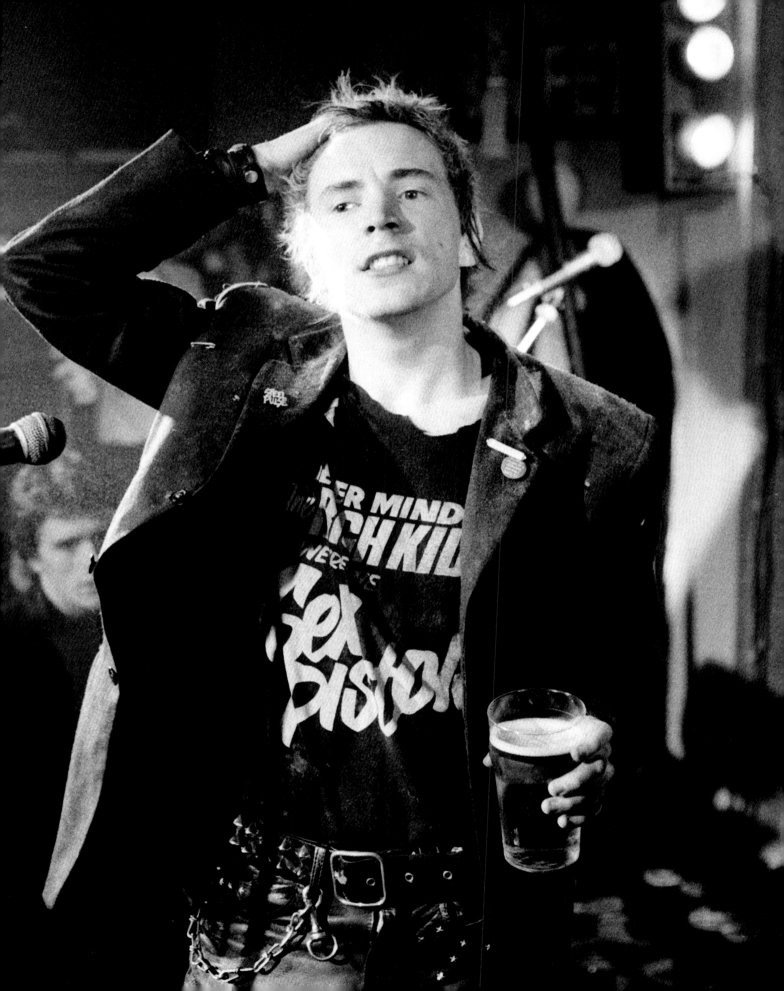

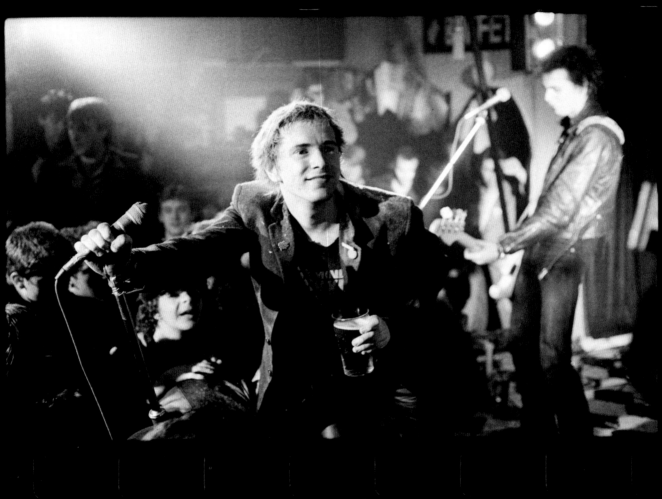

6 → 6A

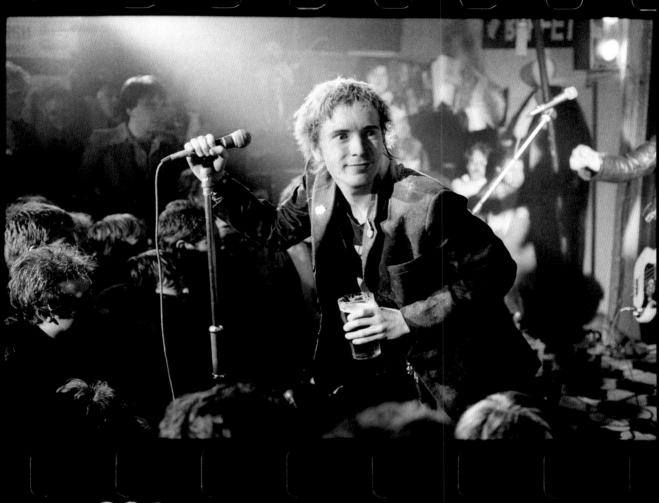

36A ↗7

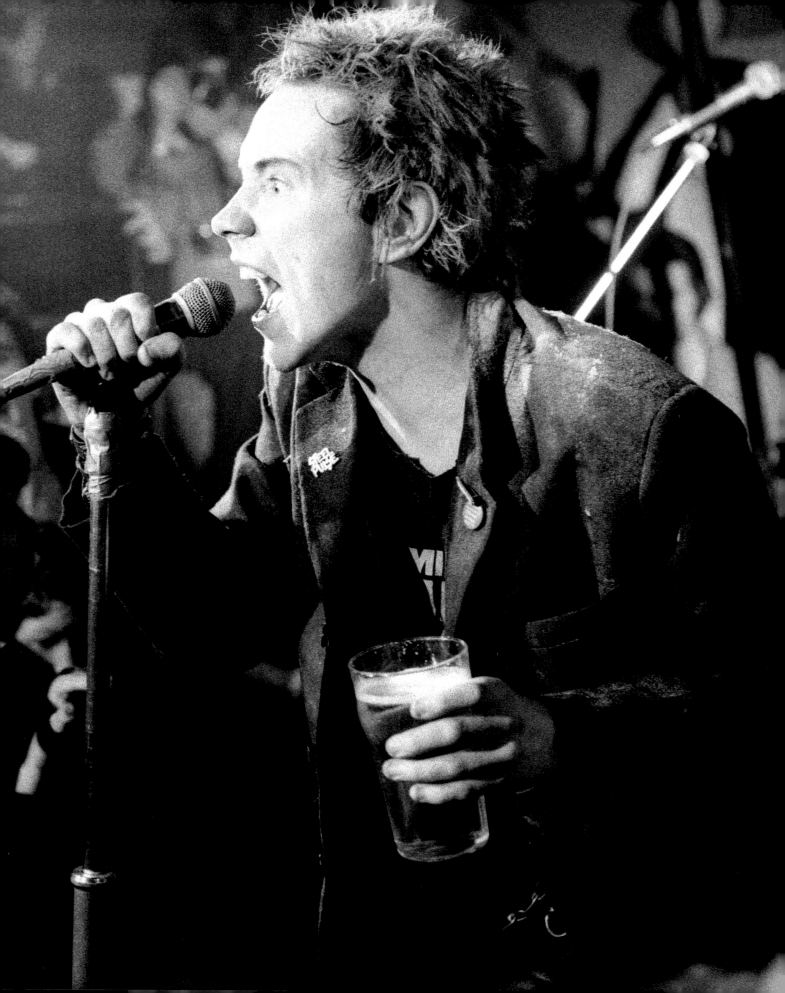

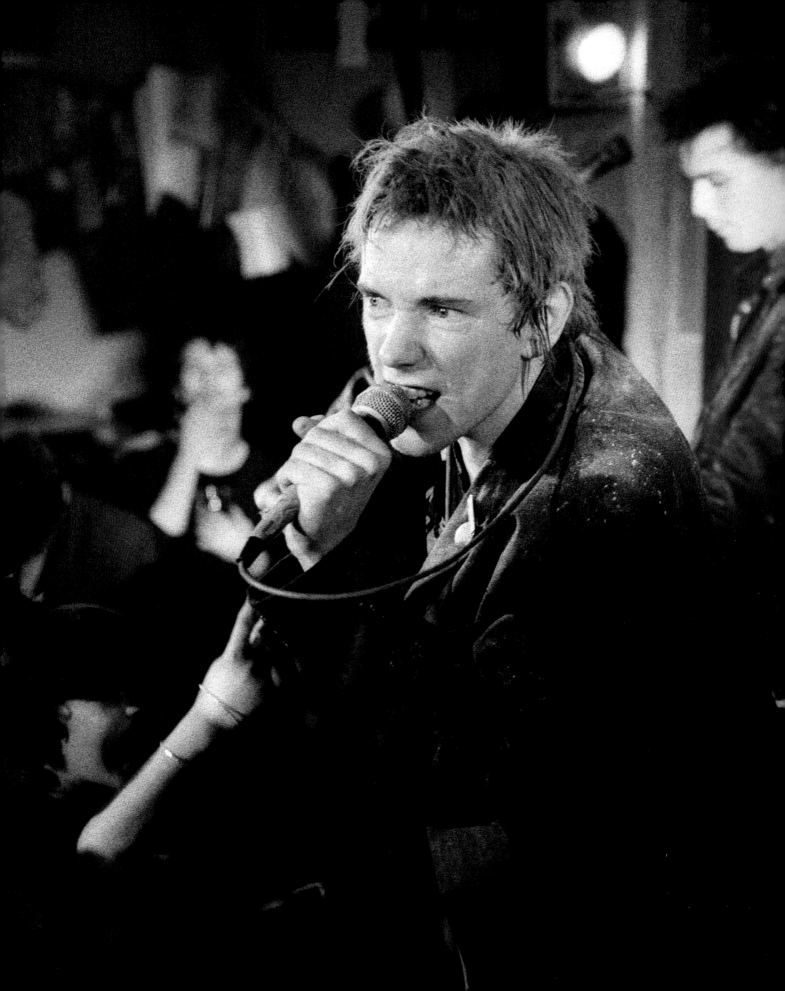

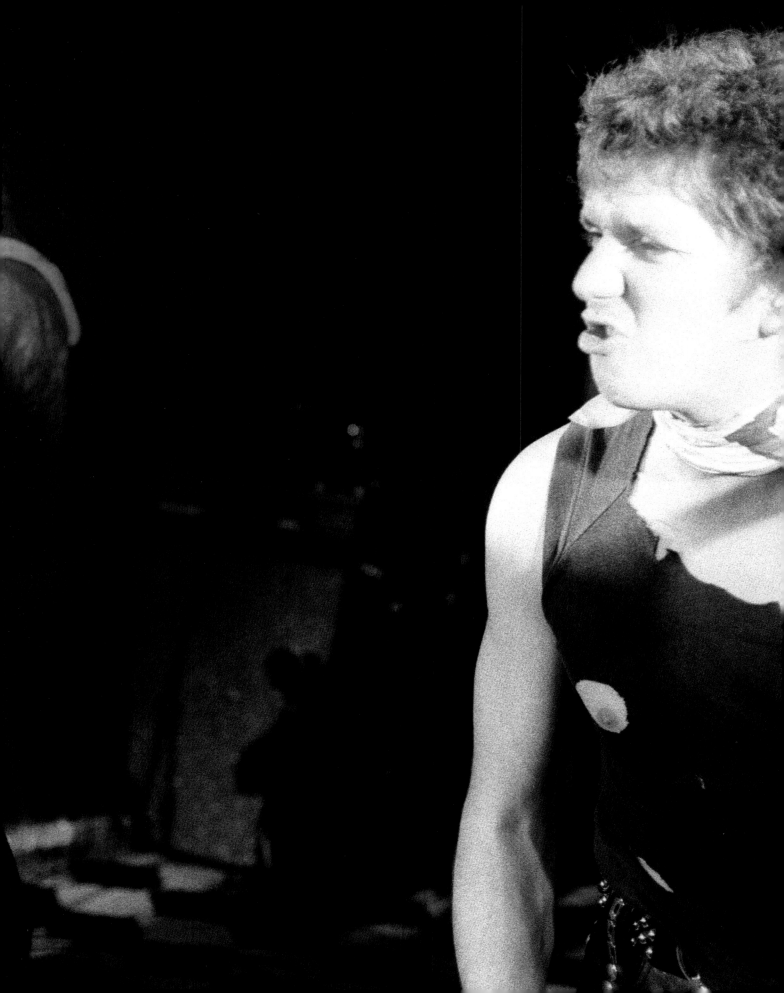

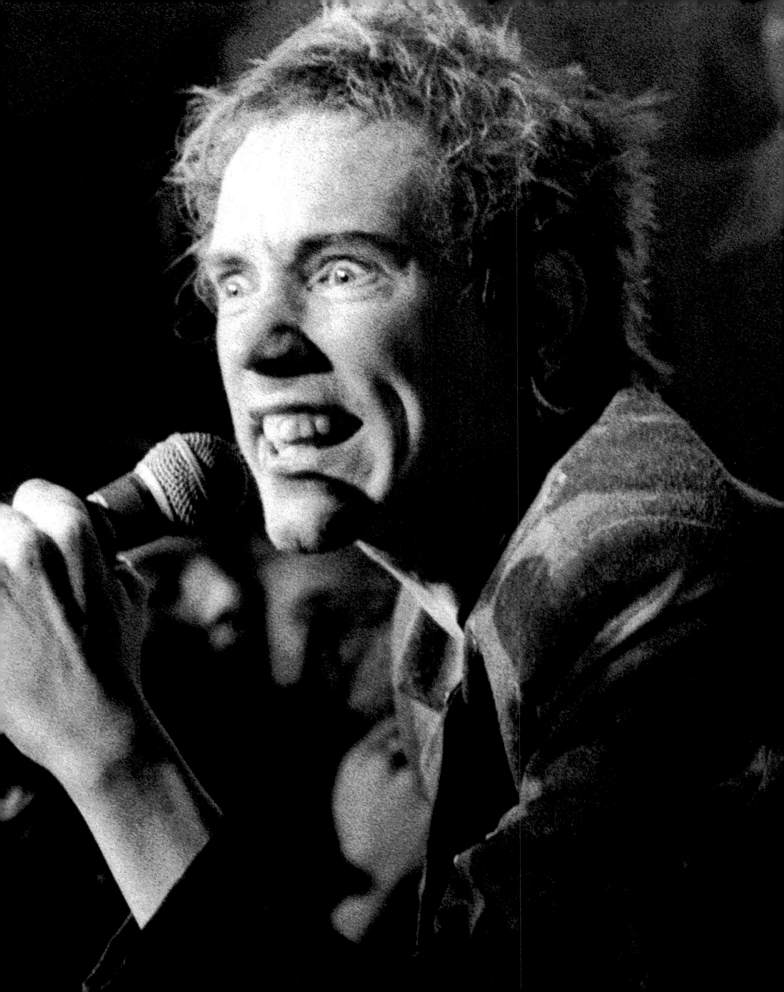

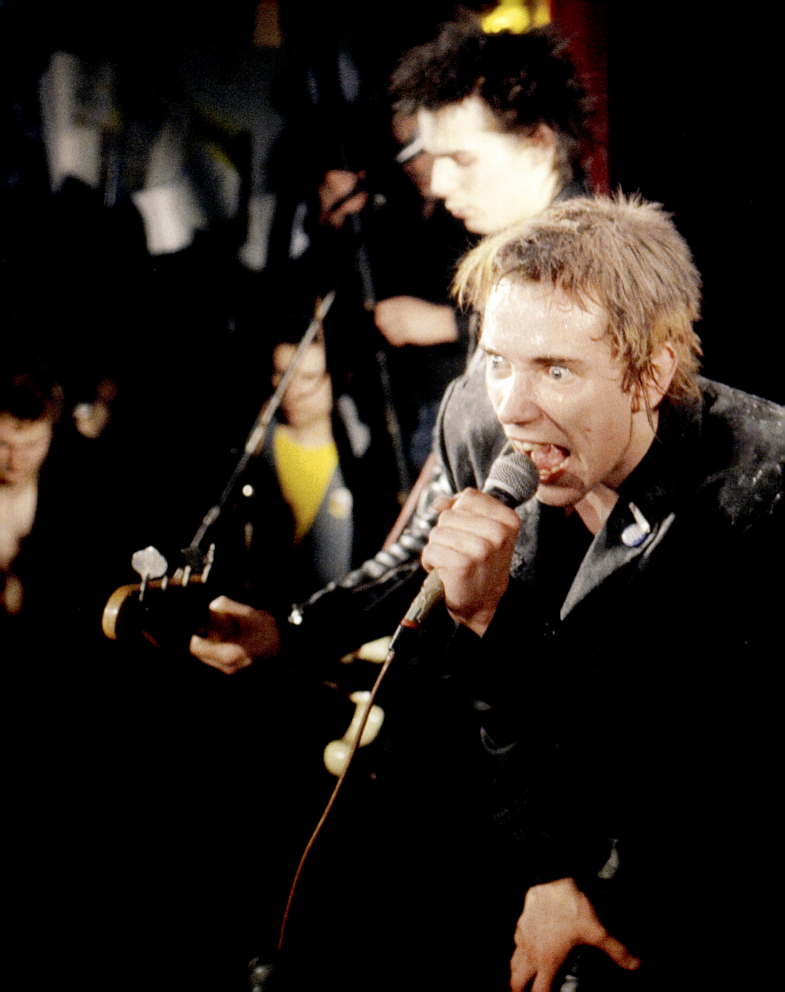

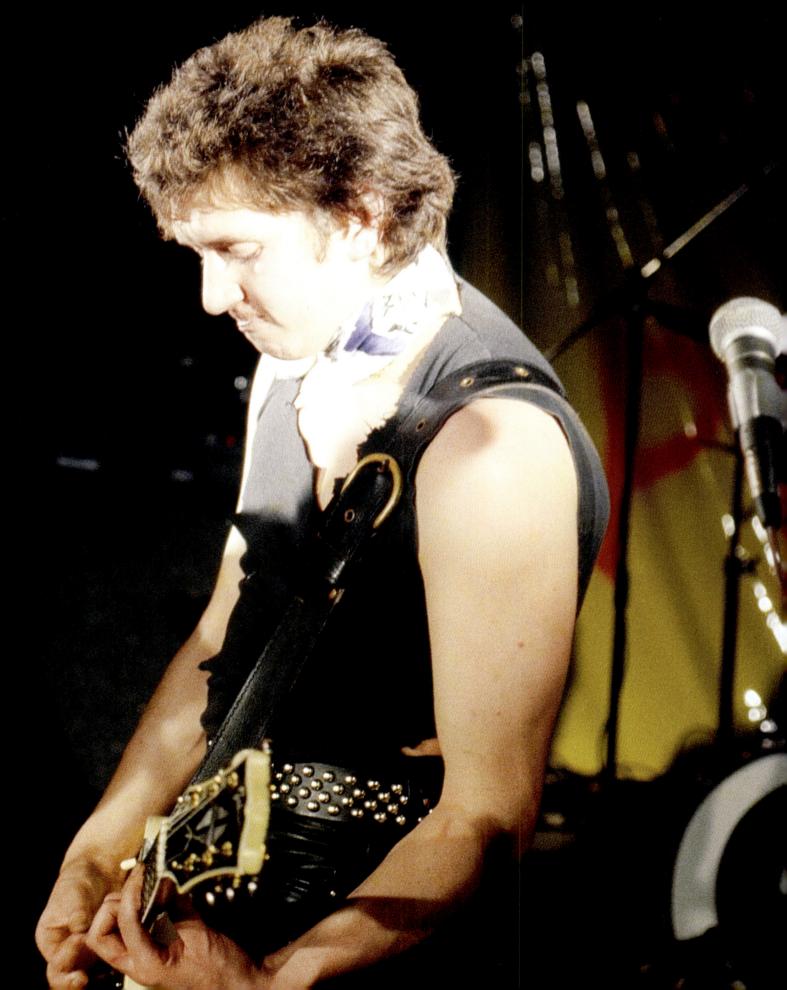

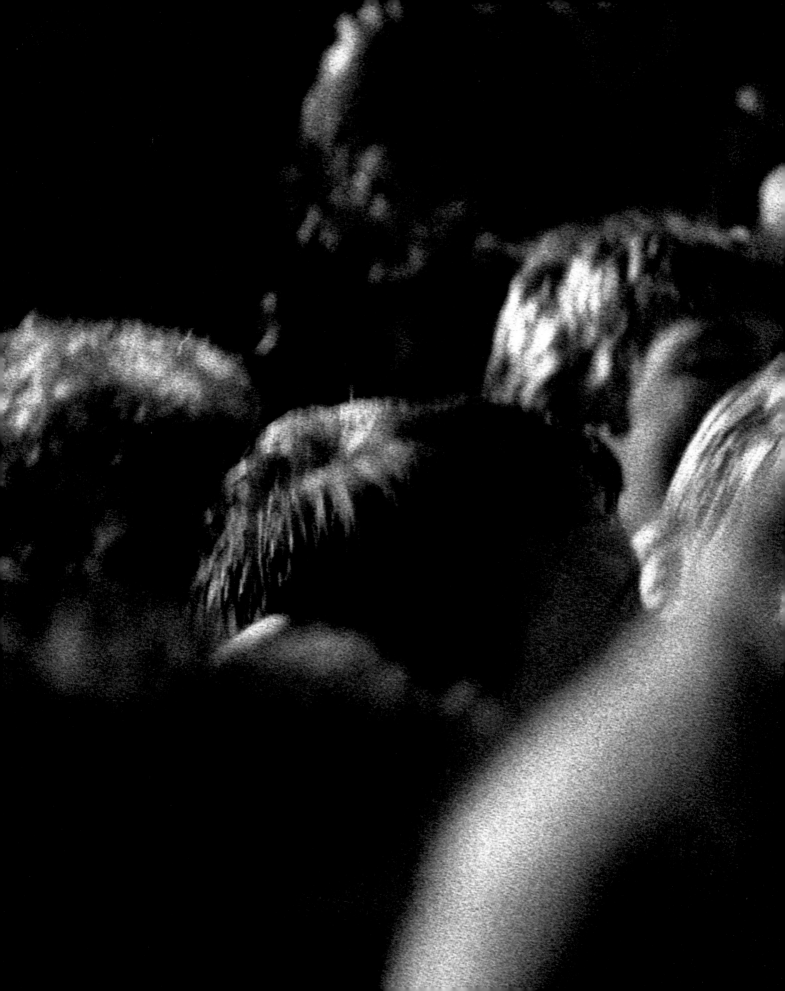

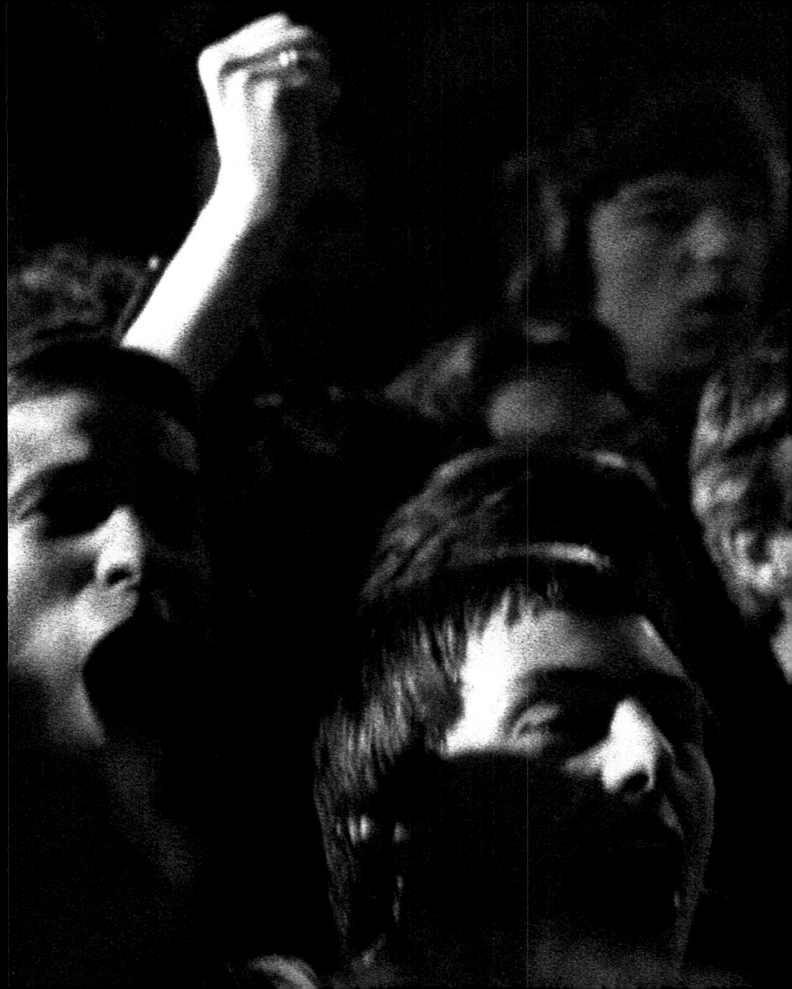

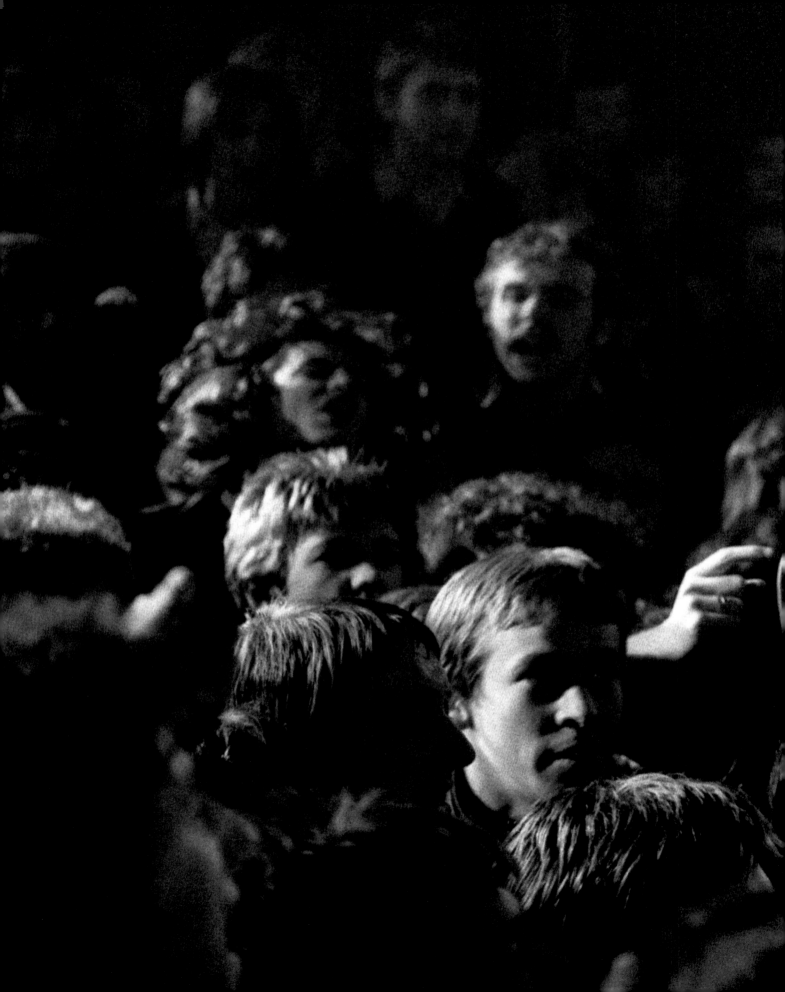

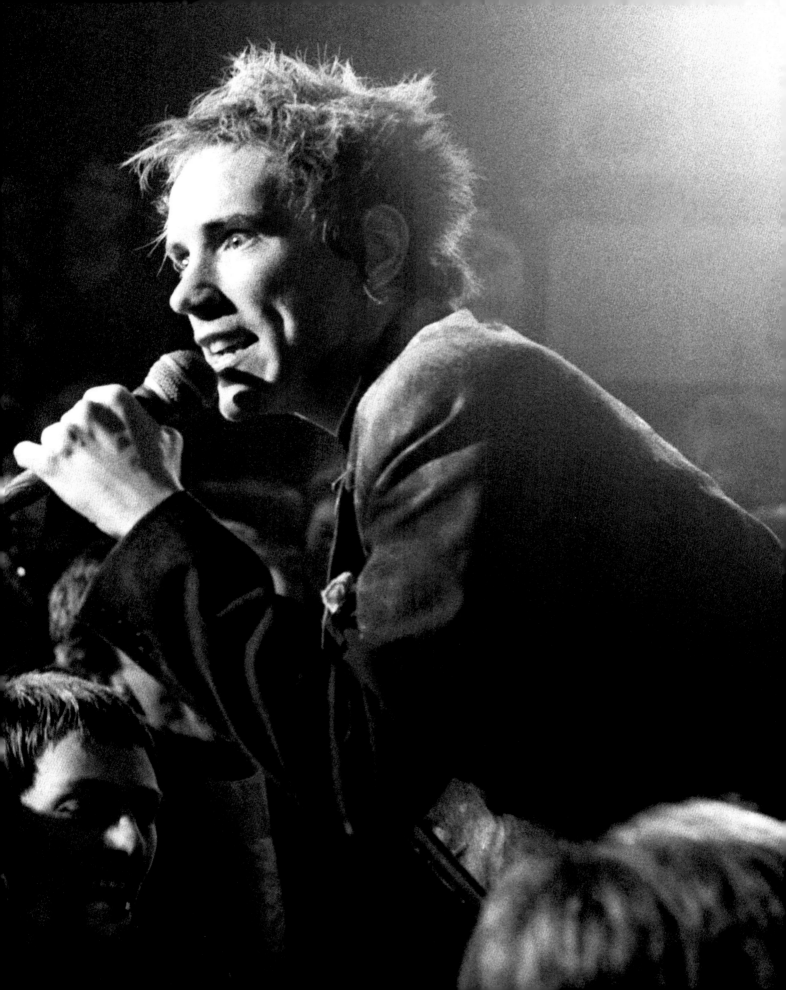

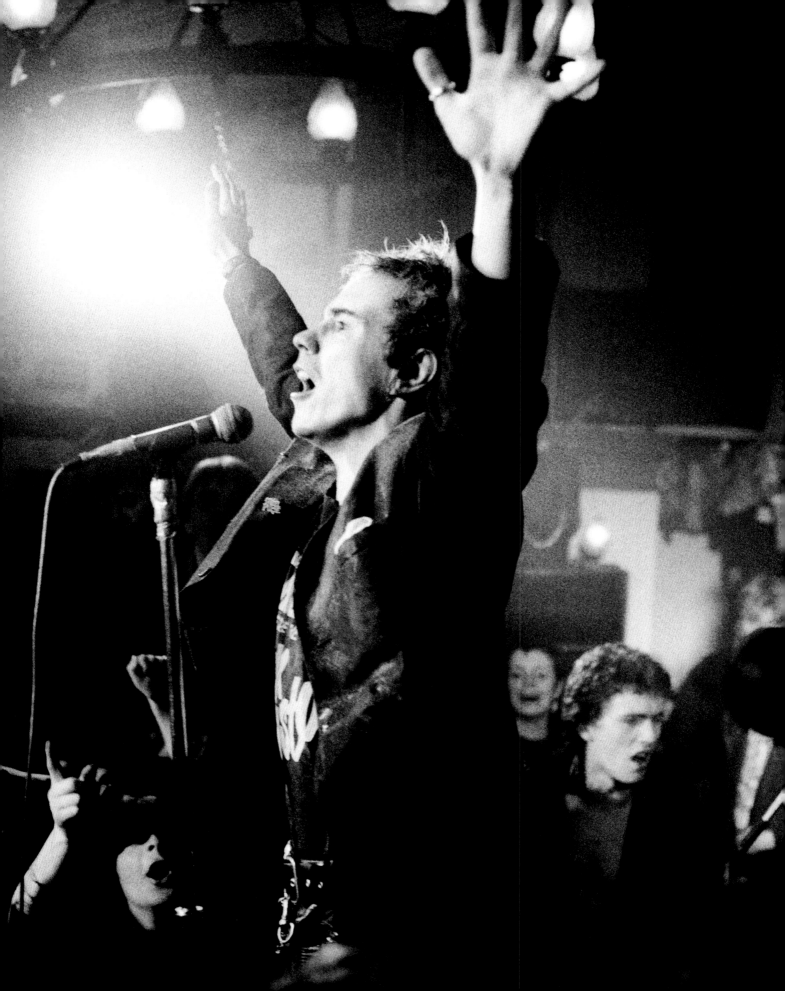

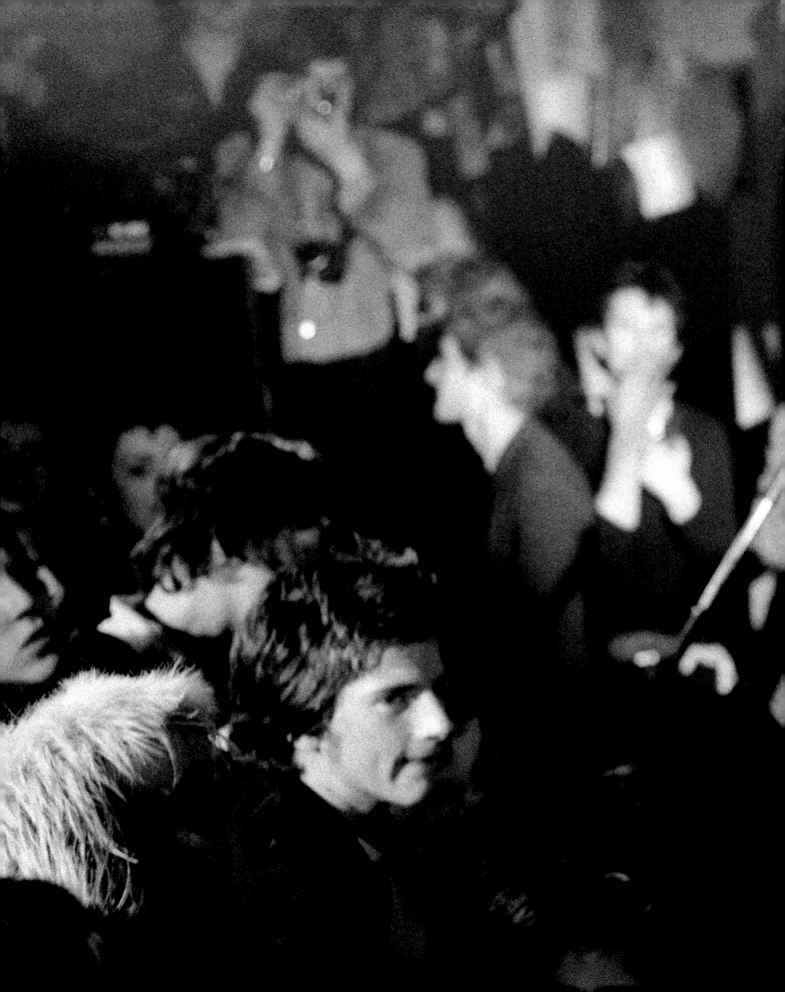

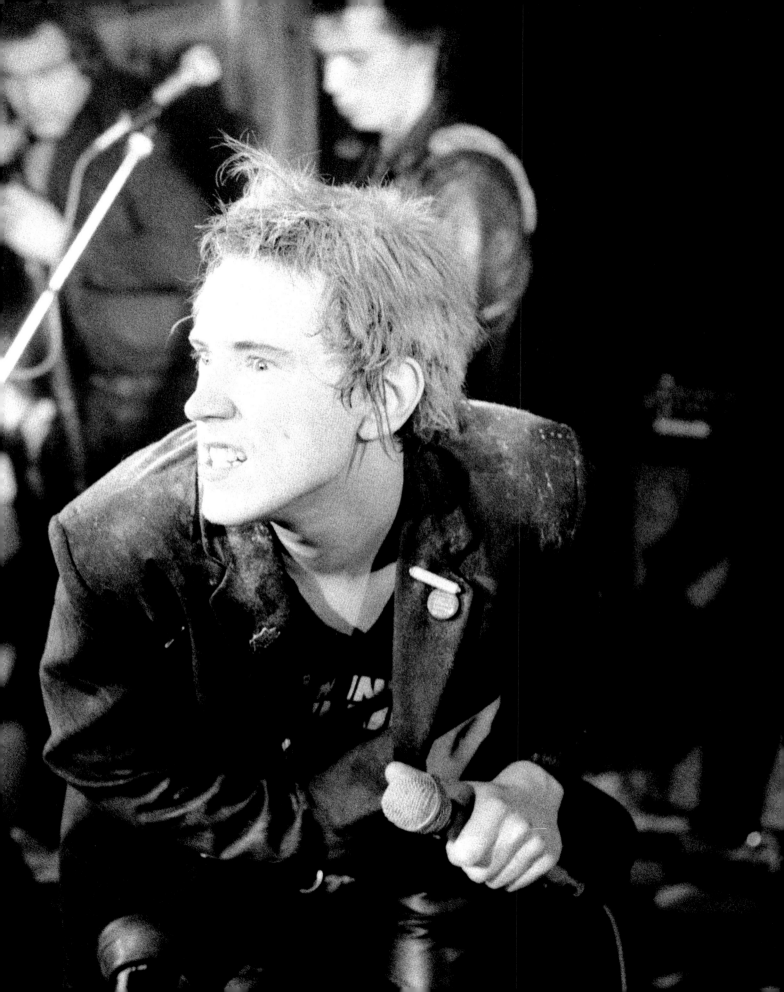

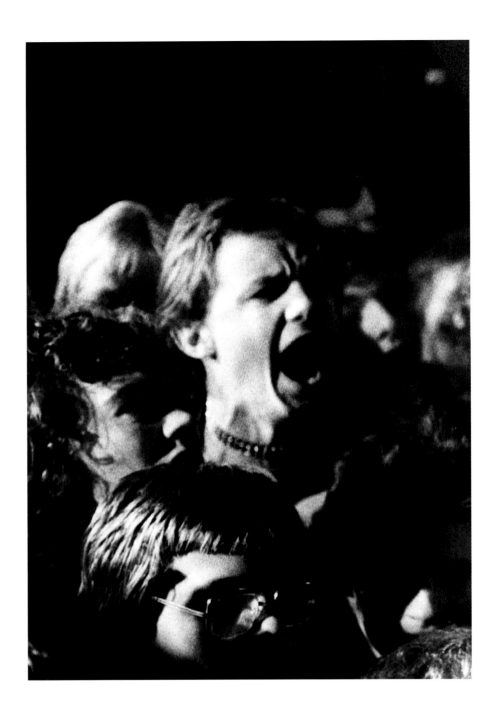

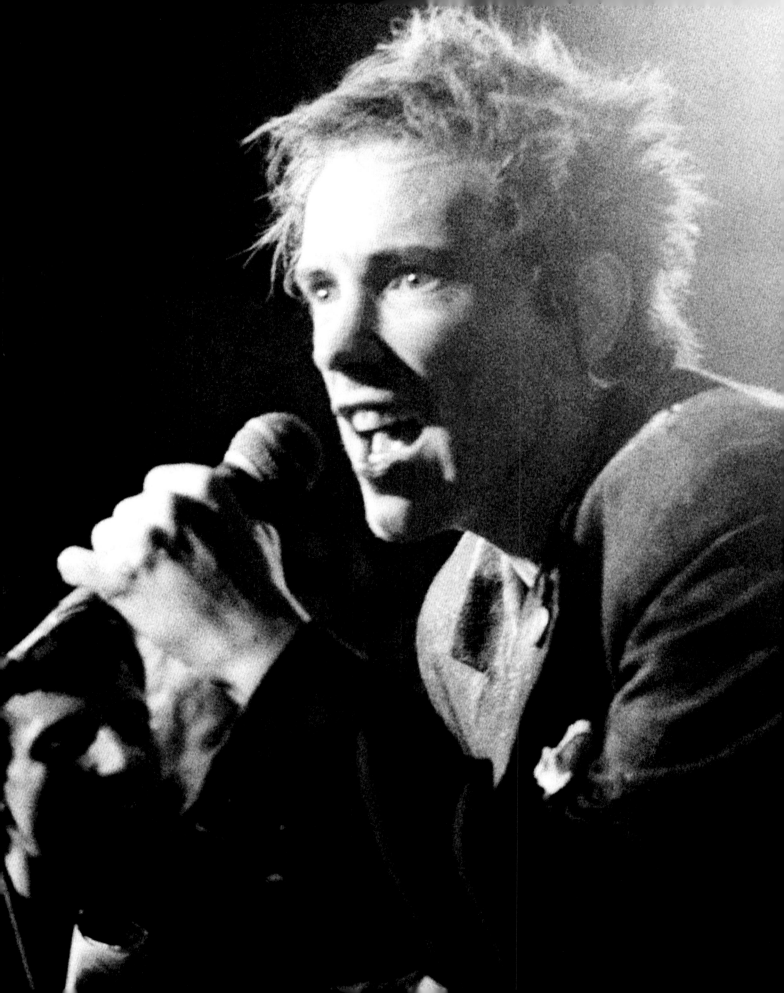

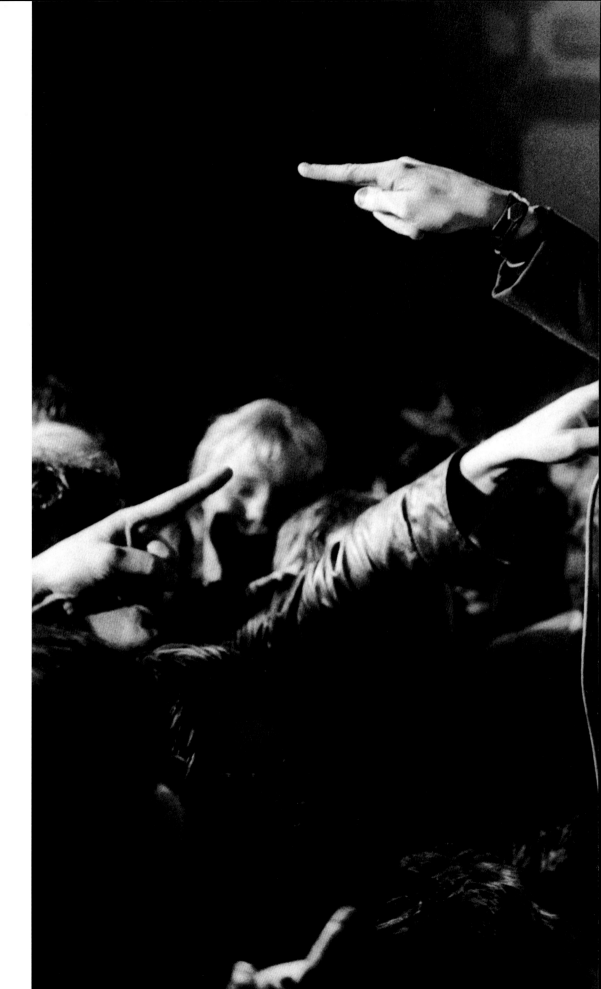

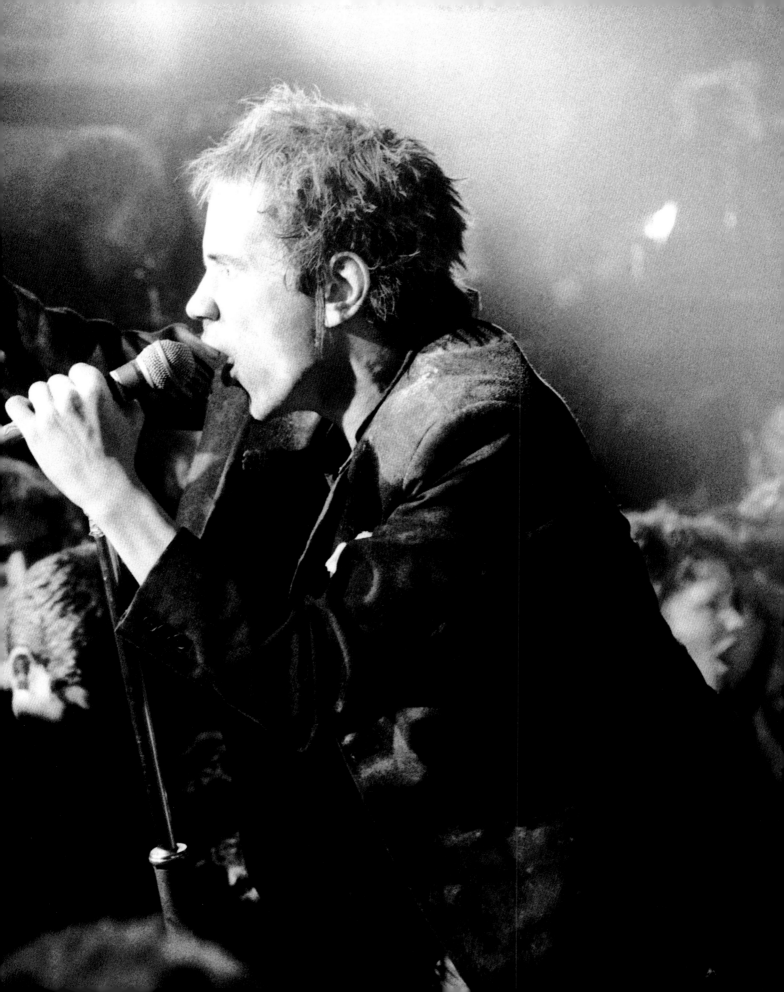

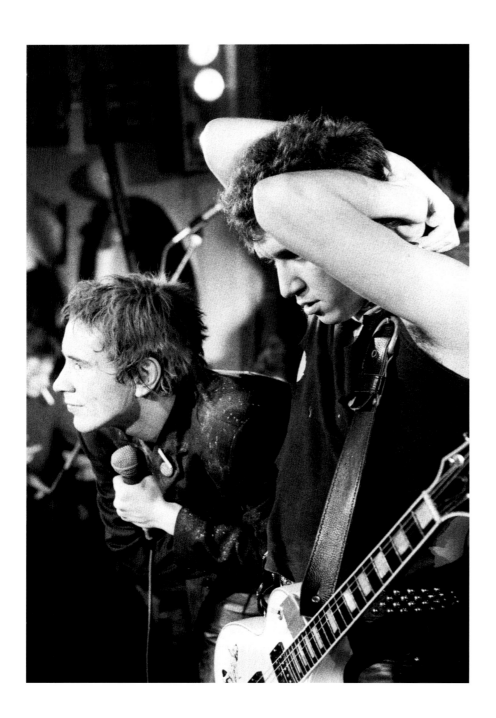

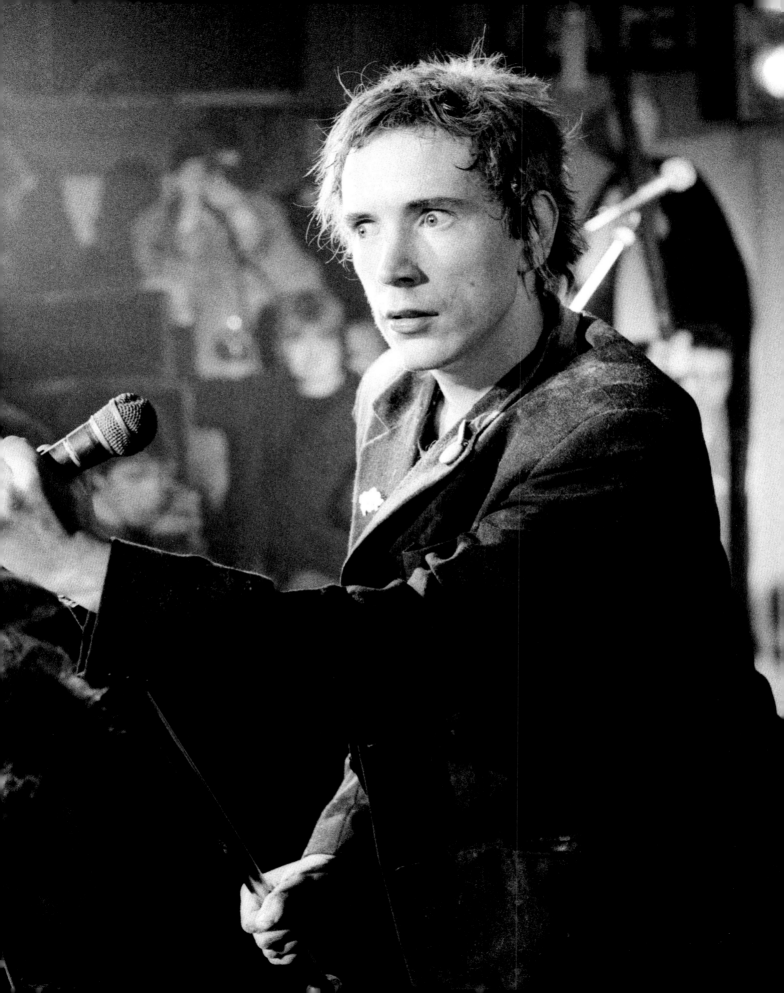

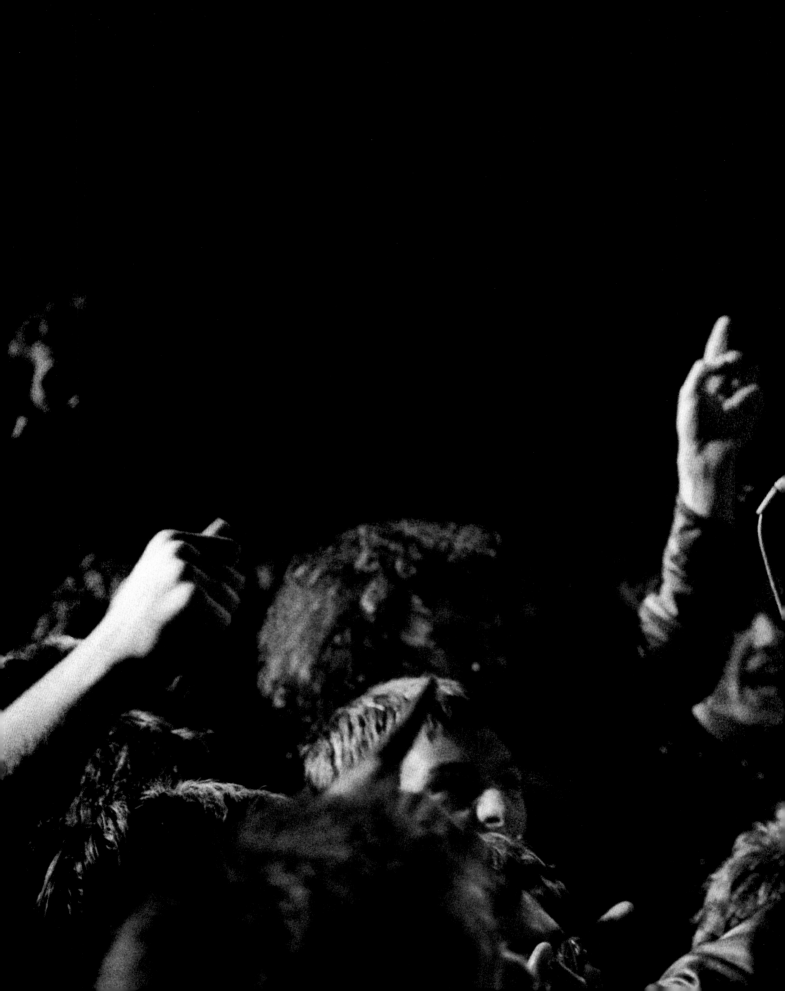

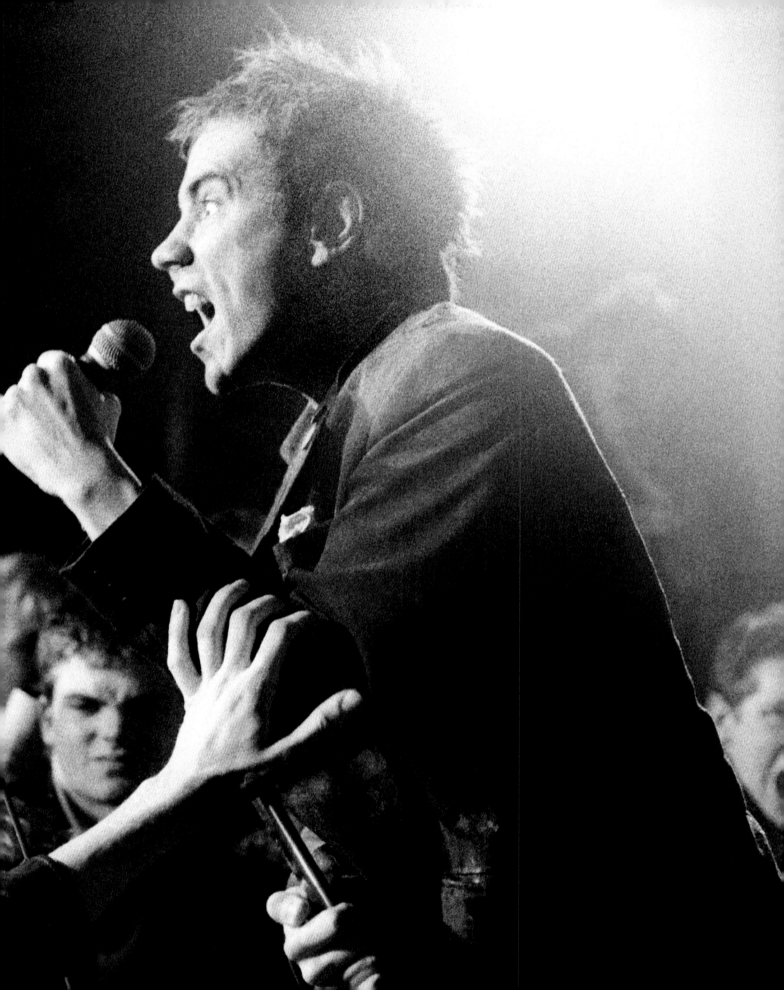

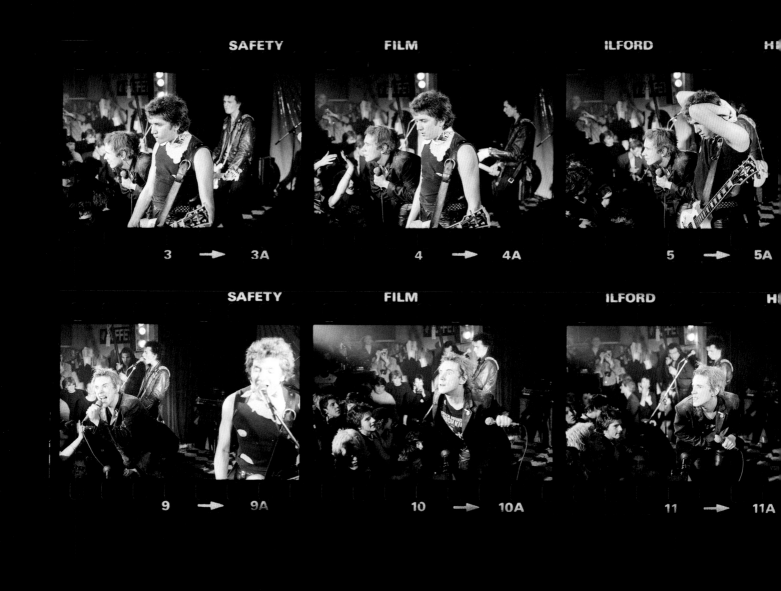

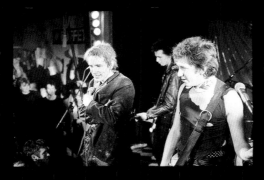

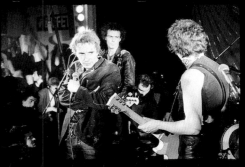

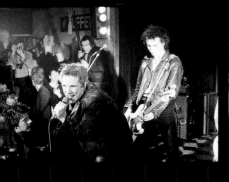

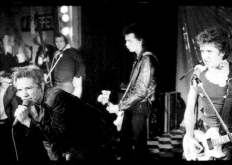

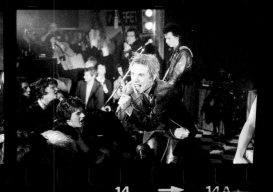

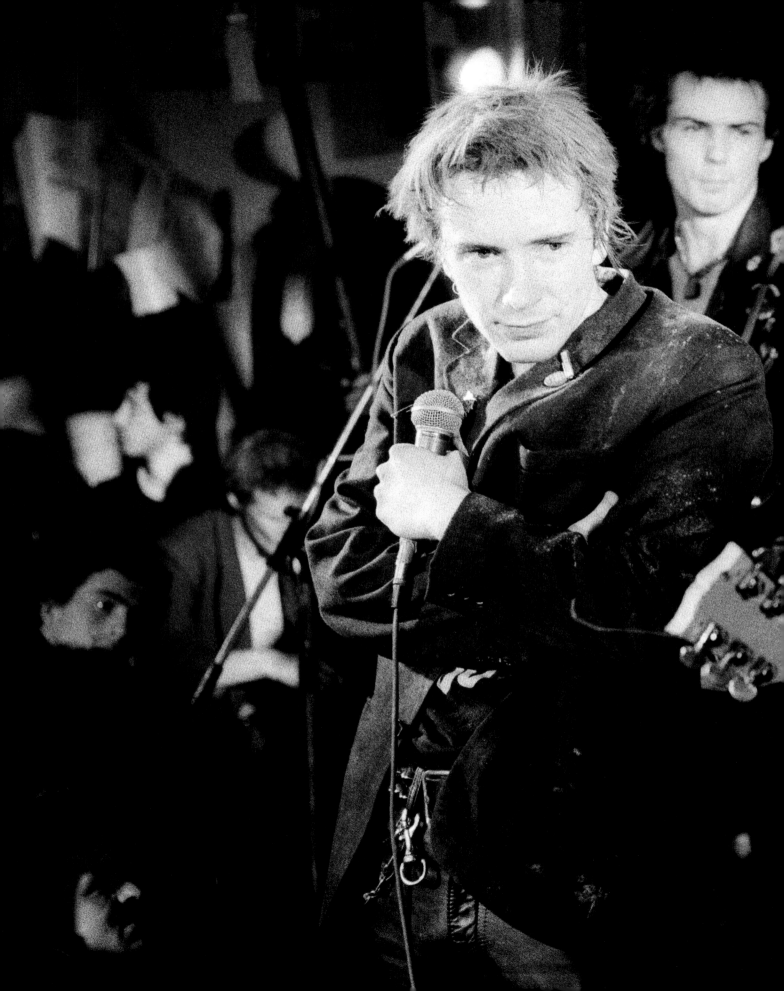

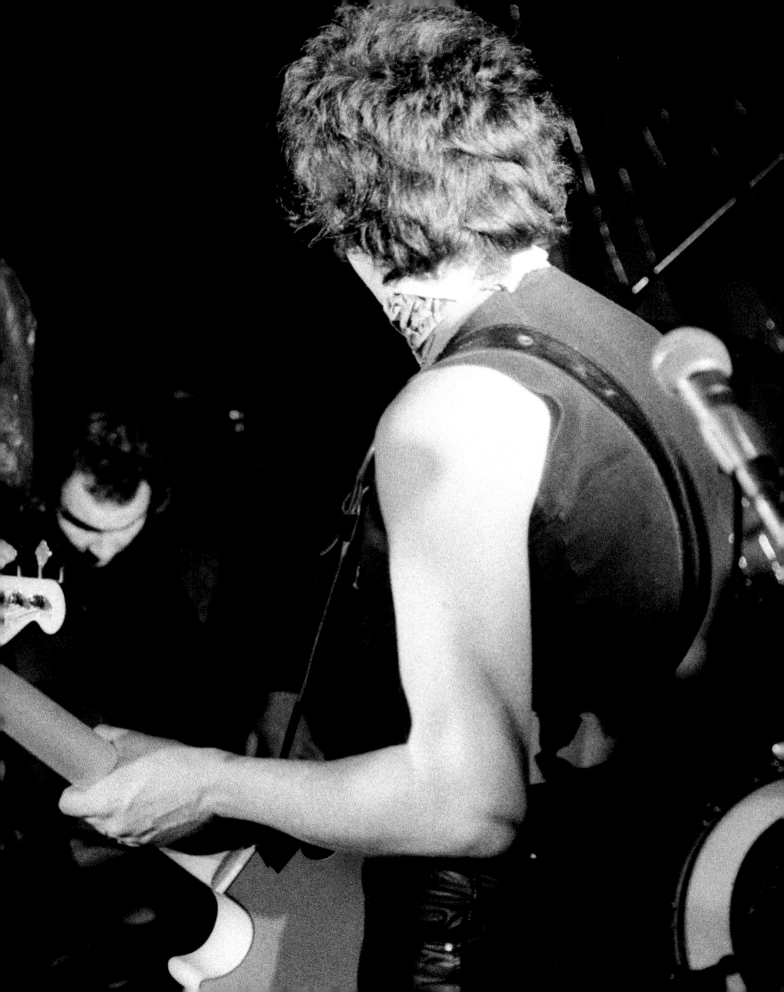

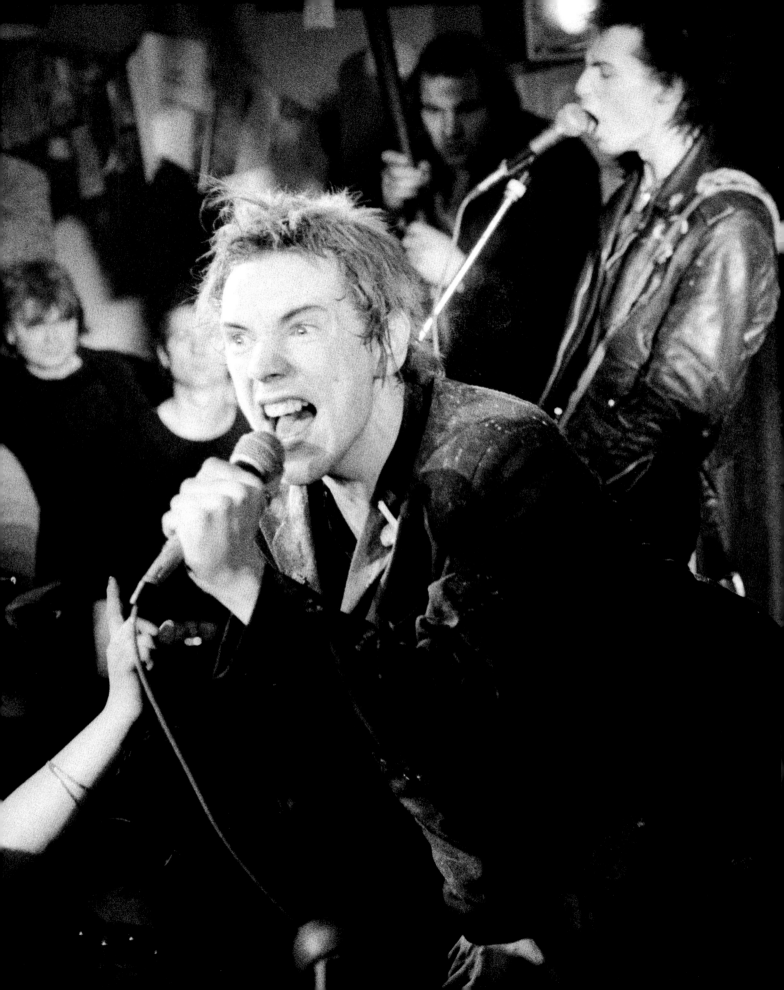

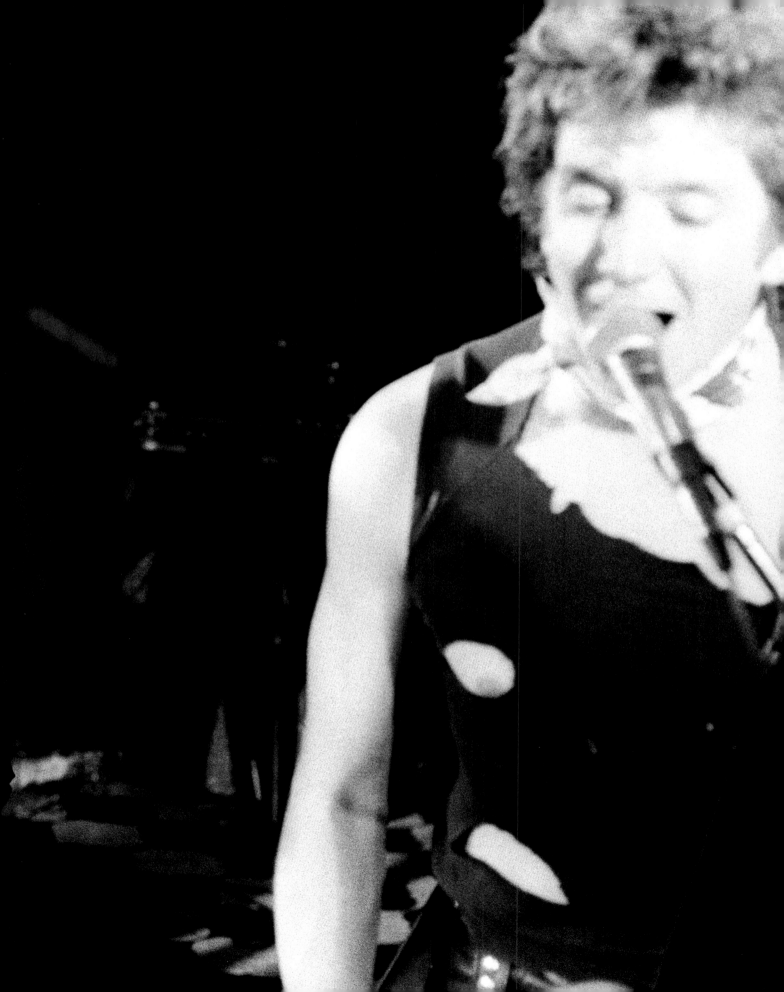

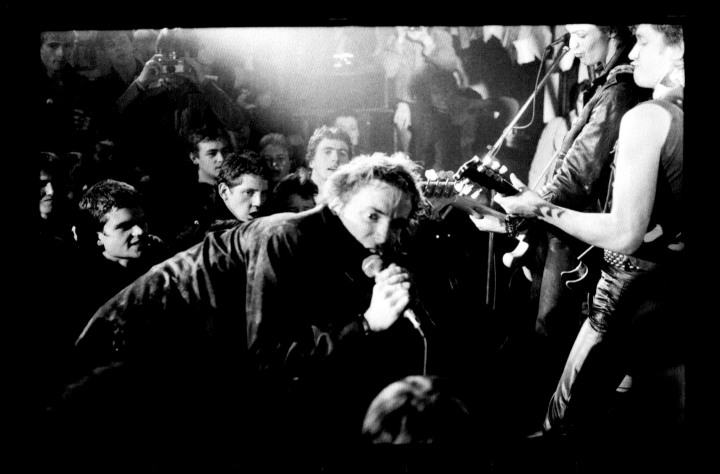

ILFORD

25A

26

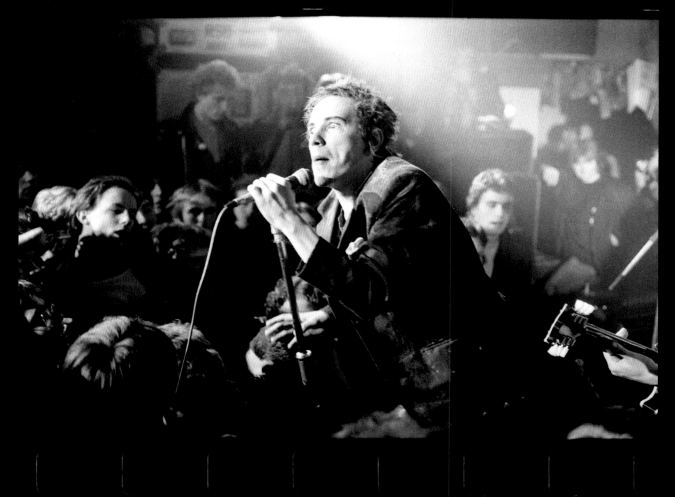

HP5

▶ 20A 21

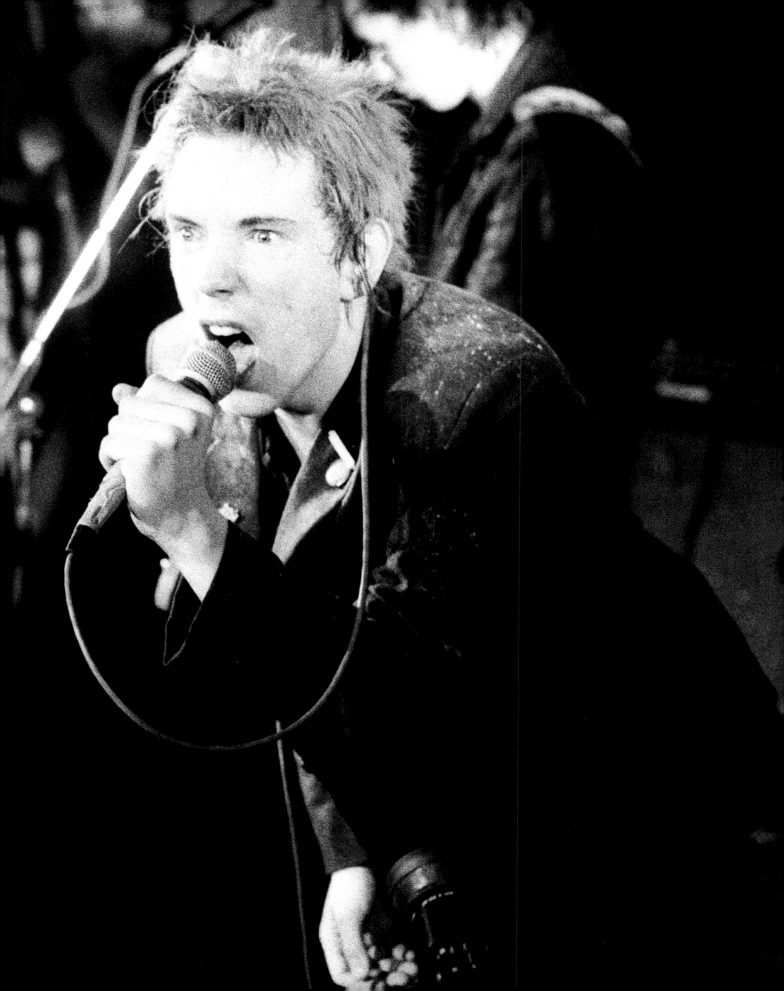

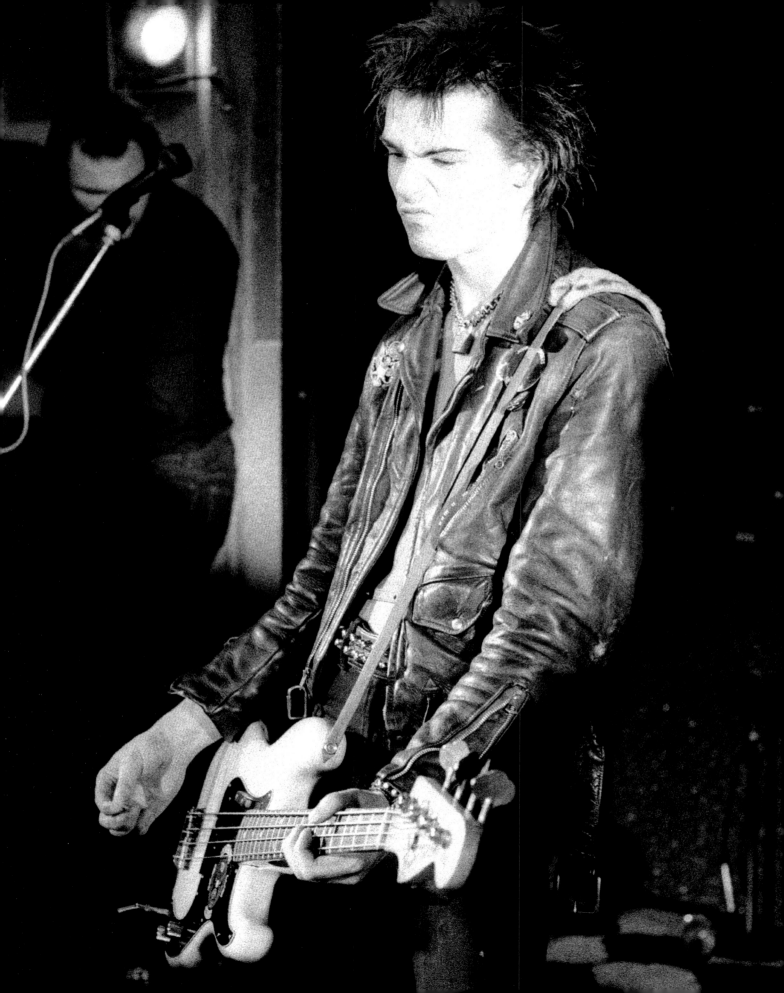

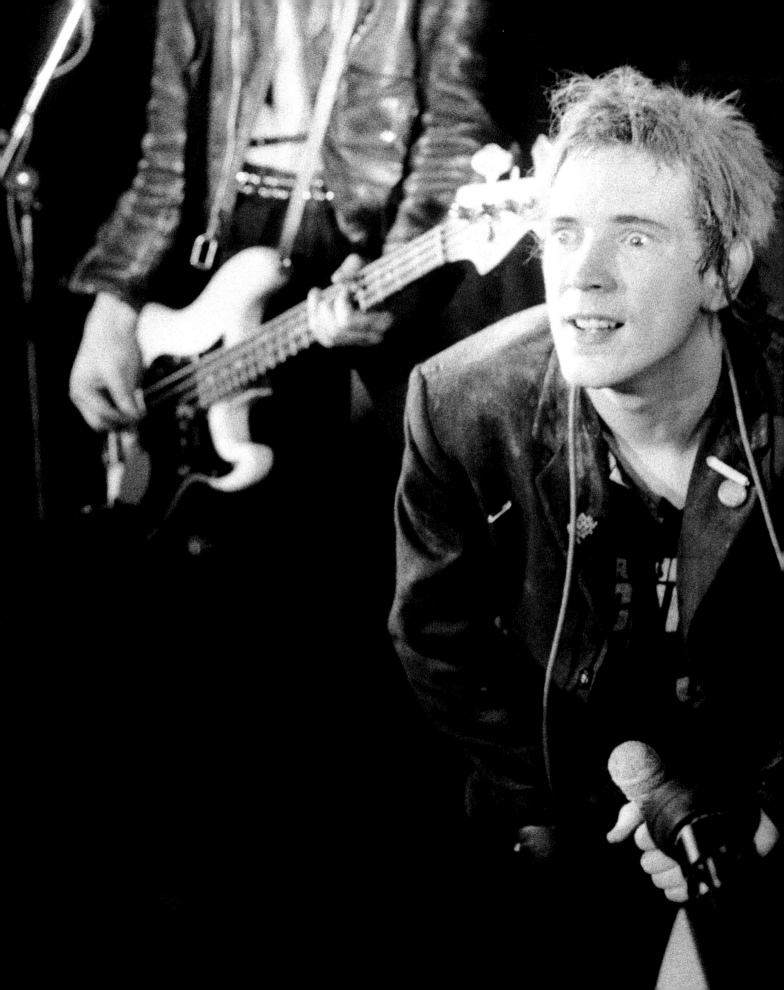

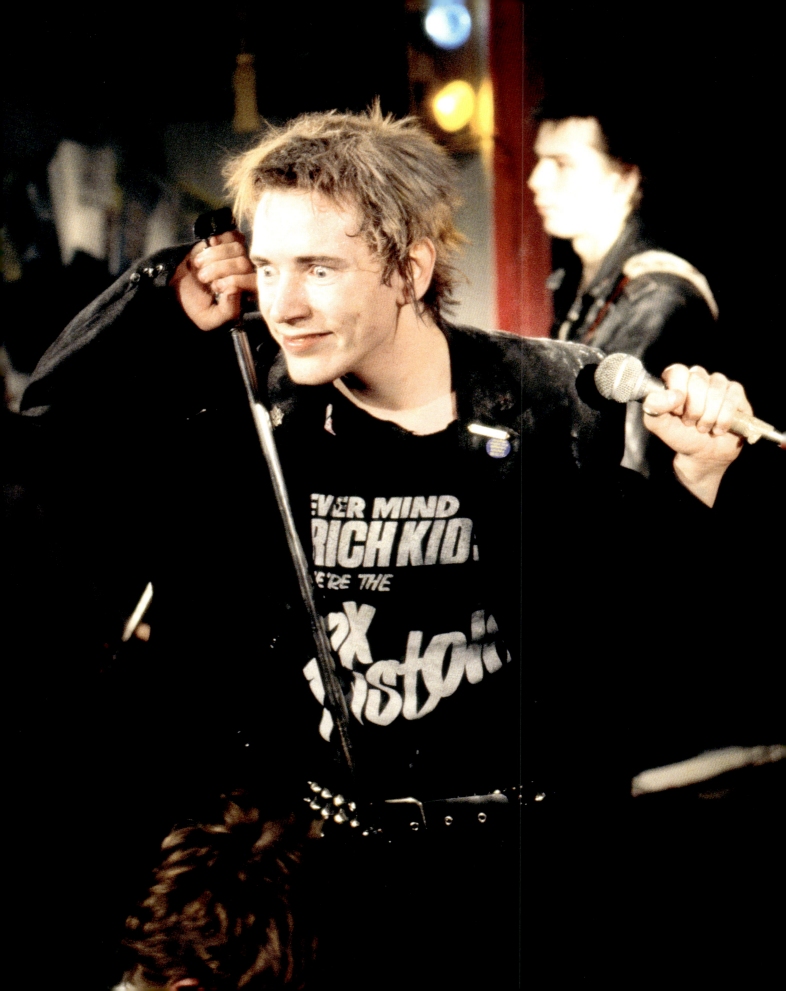

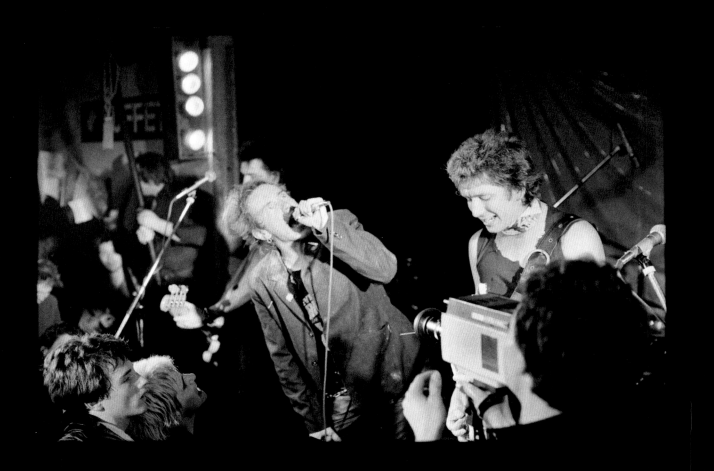

3 → 3A

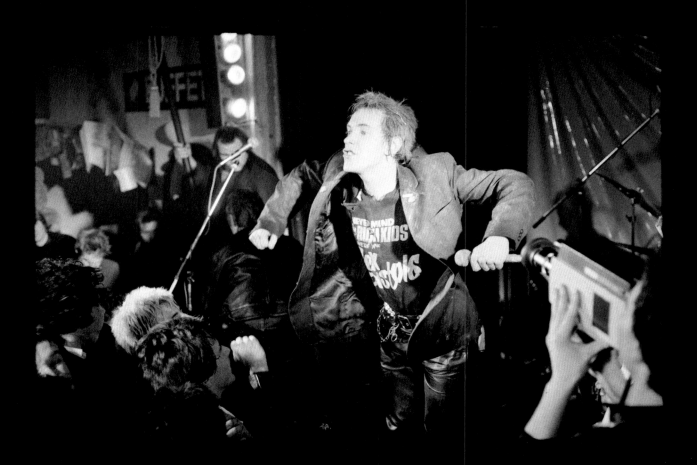

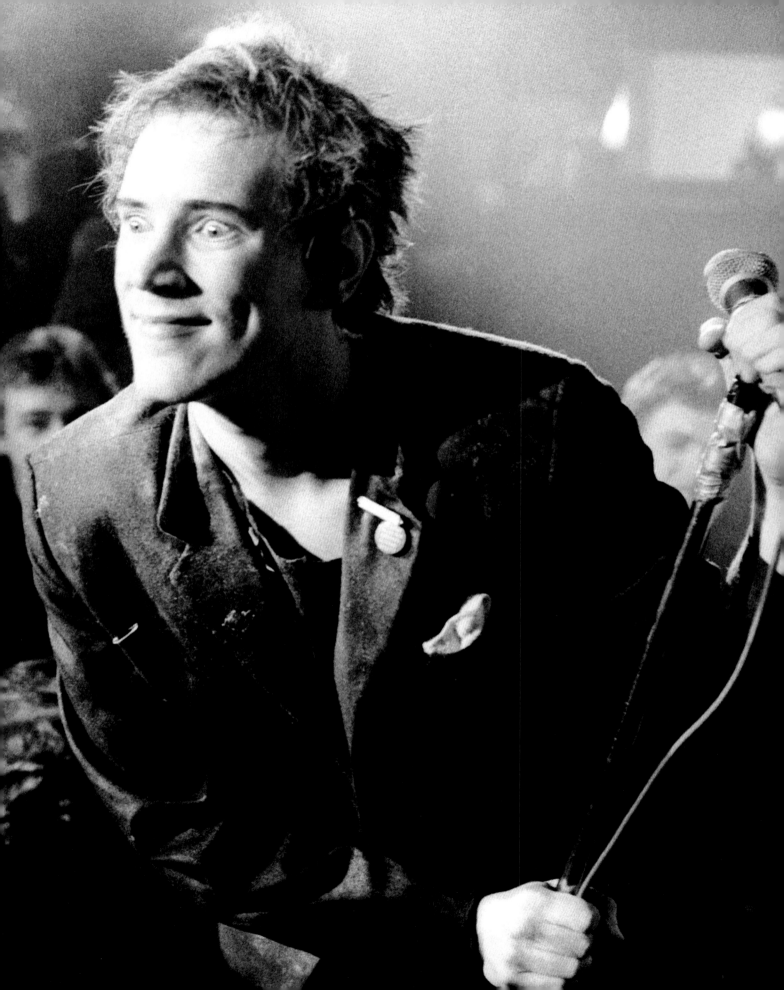

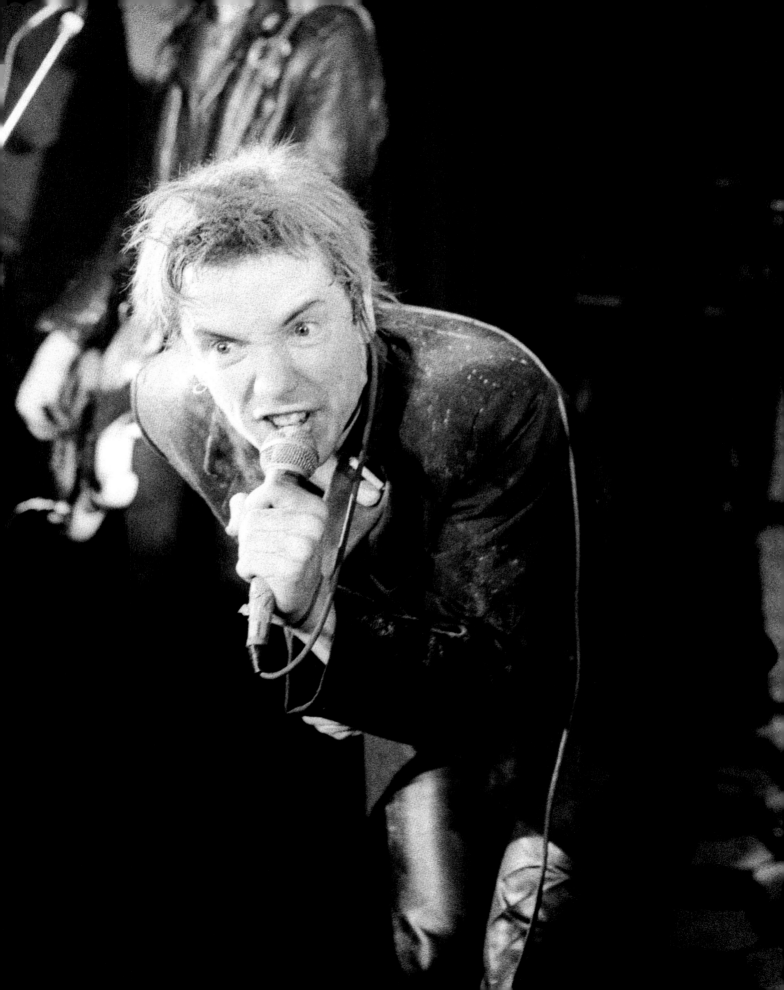

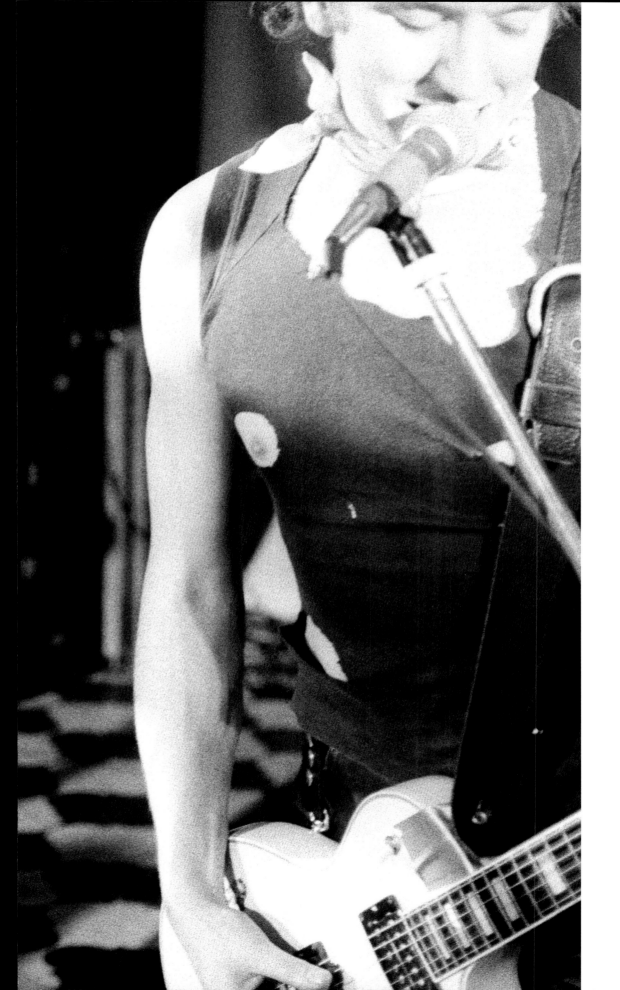

I THINK THE SEX PISTOLS
FINISHED IN HUDDERSFIELD.
AMERICA WAS LIKE …
DELUSIONAL. WE'D LOST
THE VIBE AND COULDN'T
GET IT BACK

JOHNNY ROTTEN

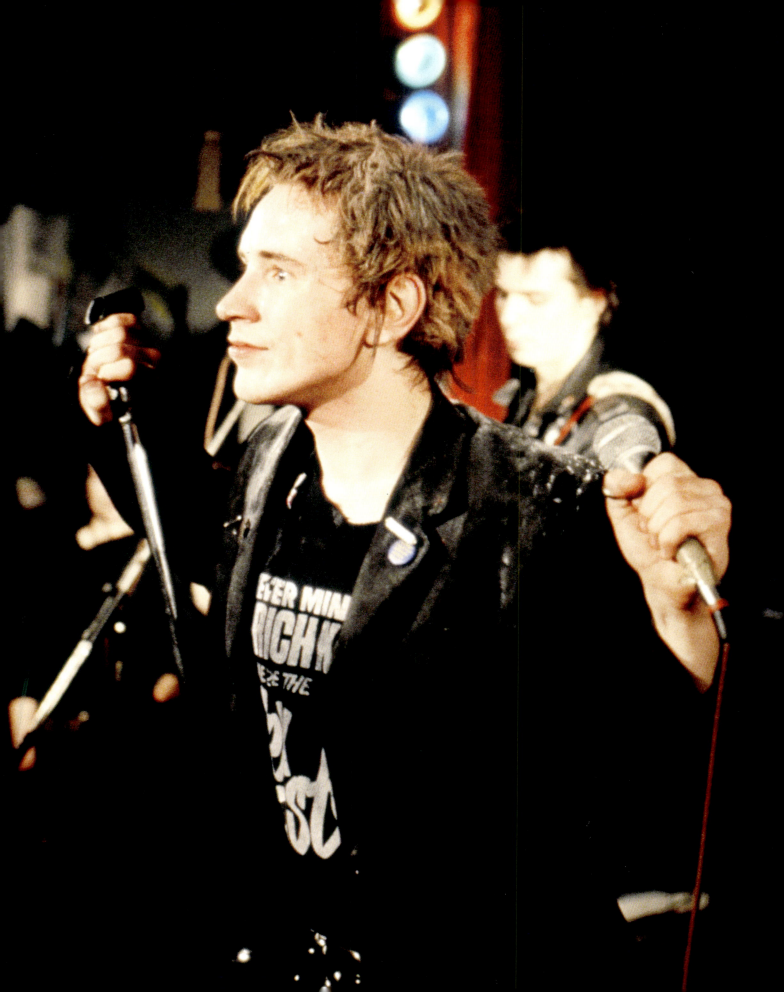

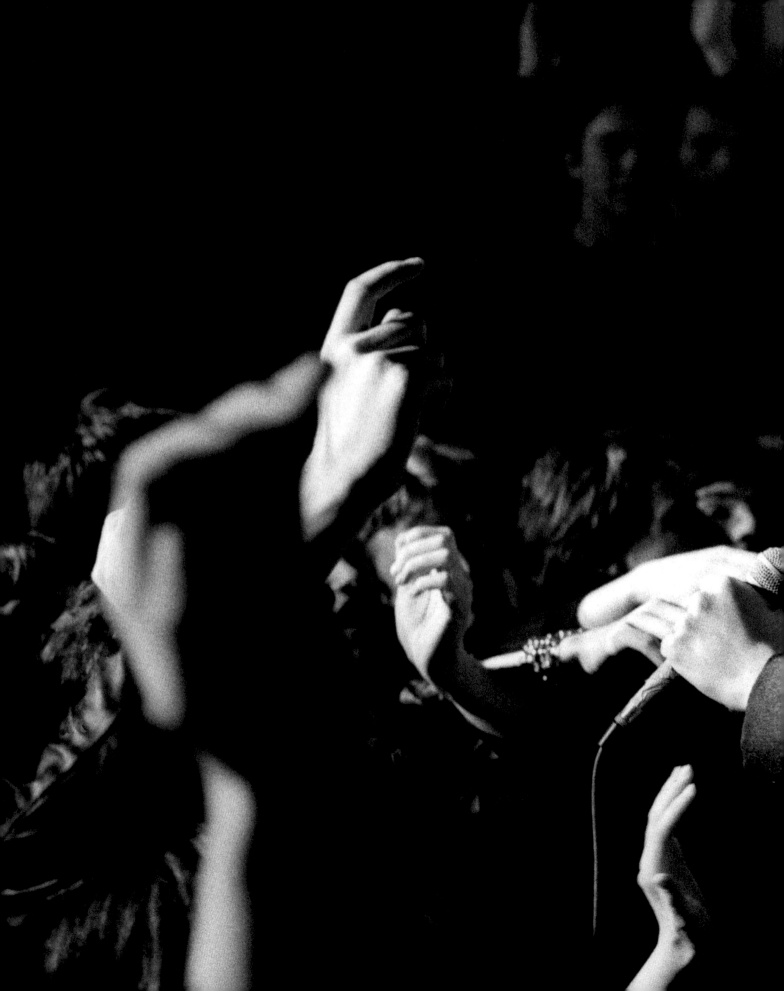

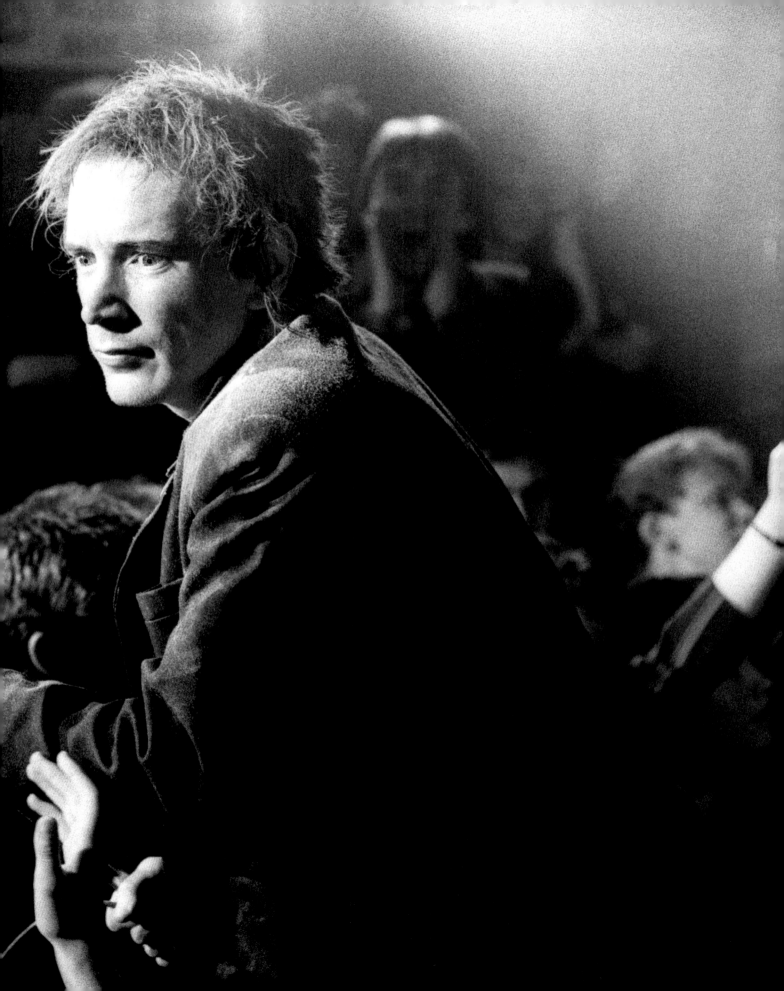

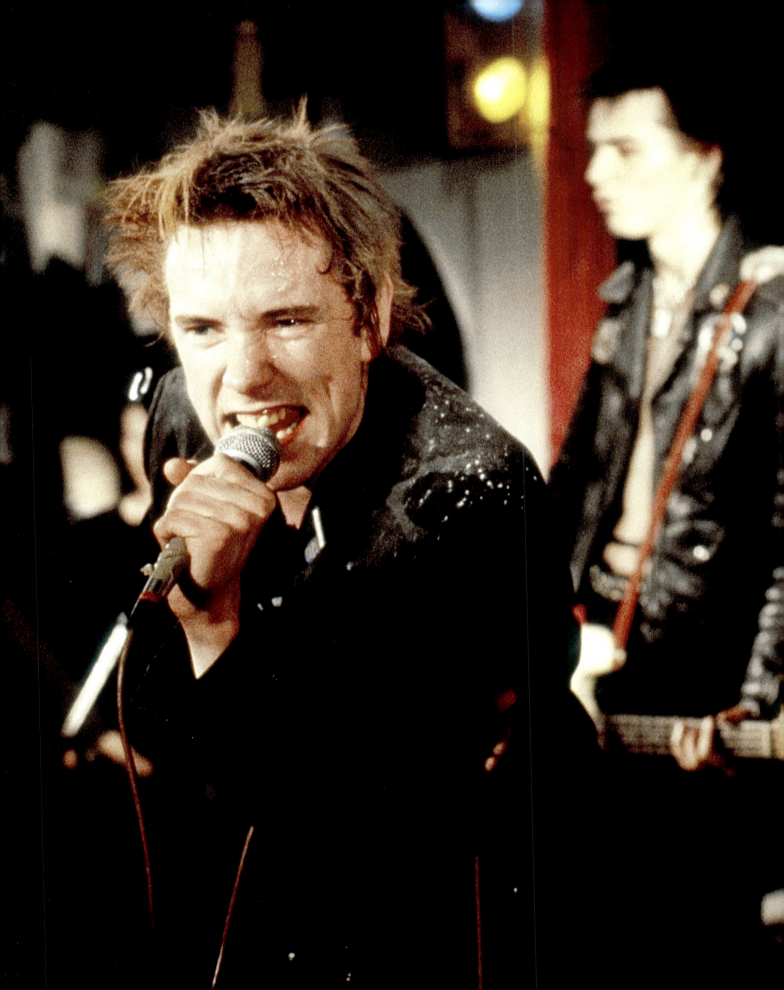

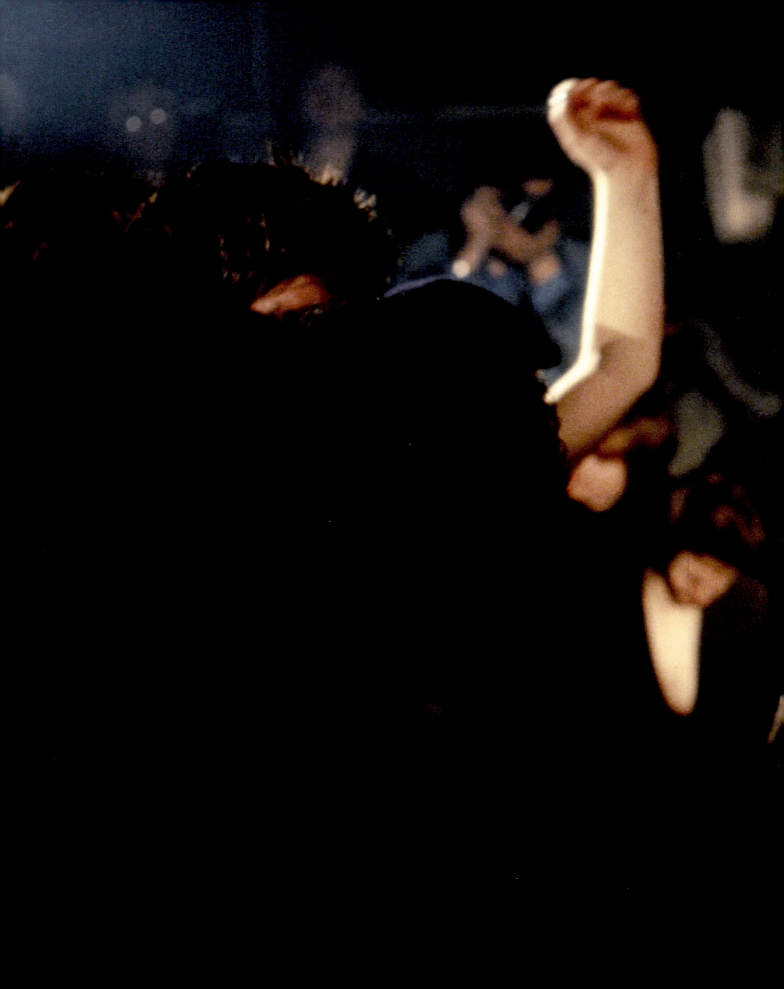

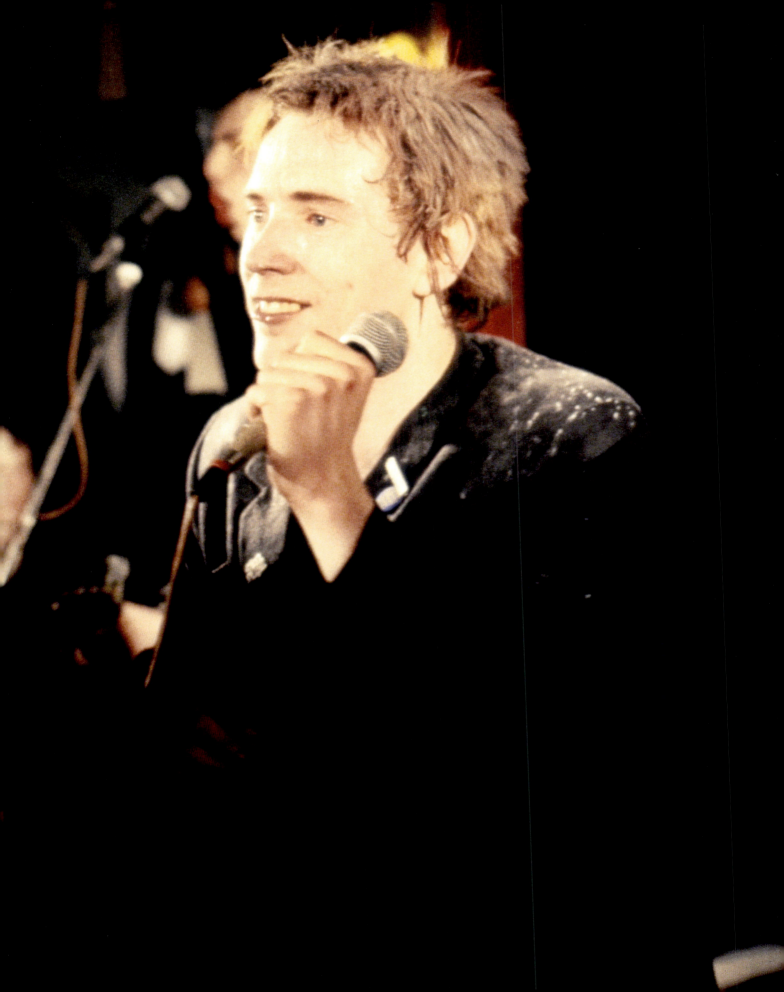

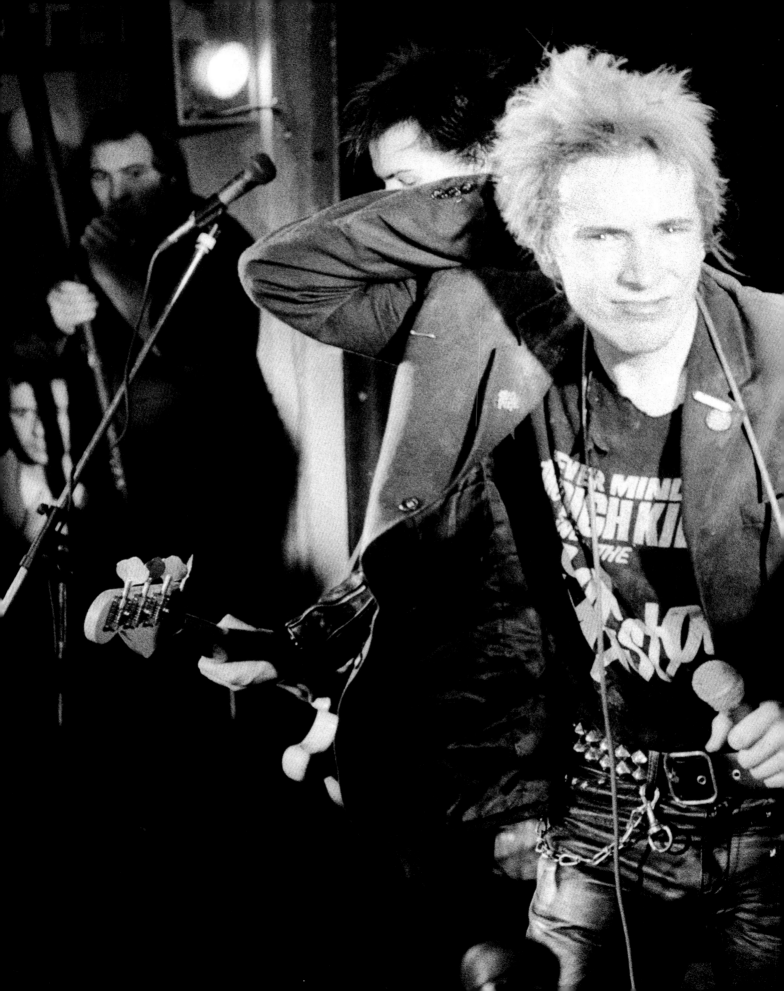

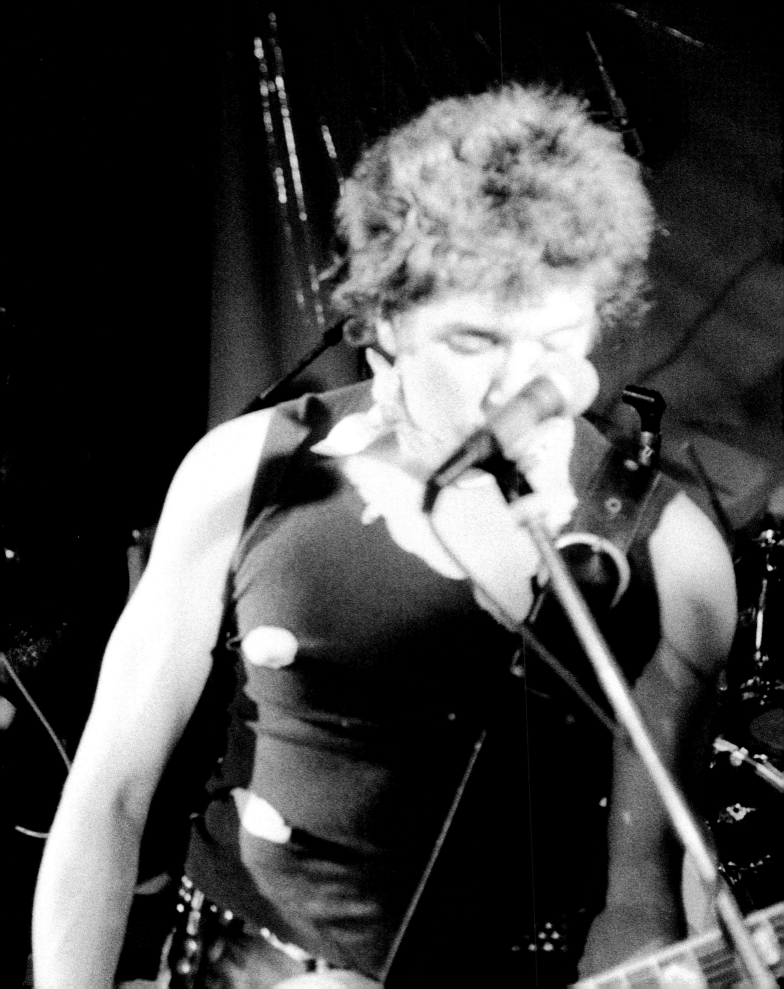

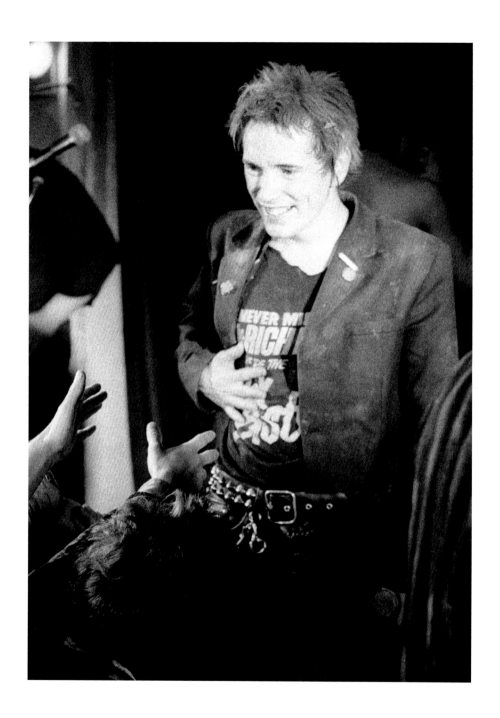

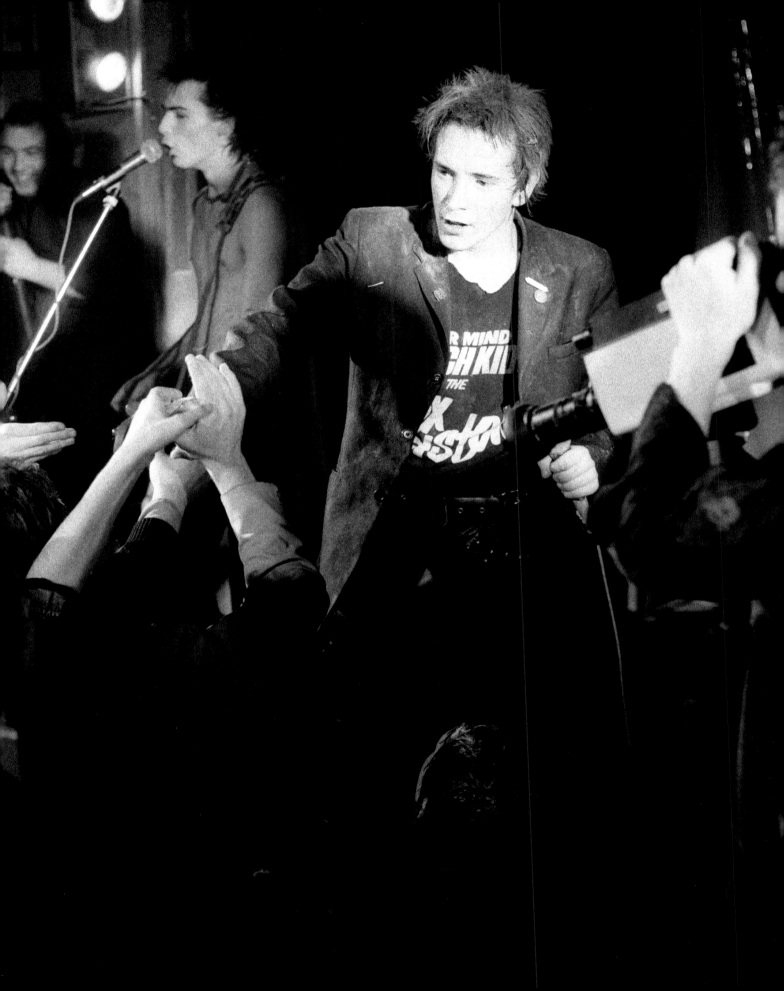

THAT GIG MADE ME FEEL
I'D ACTUALLY ACHIEVED
SOMETHING

JOHNNY ROTTEN

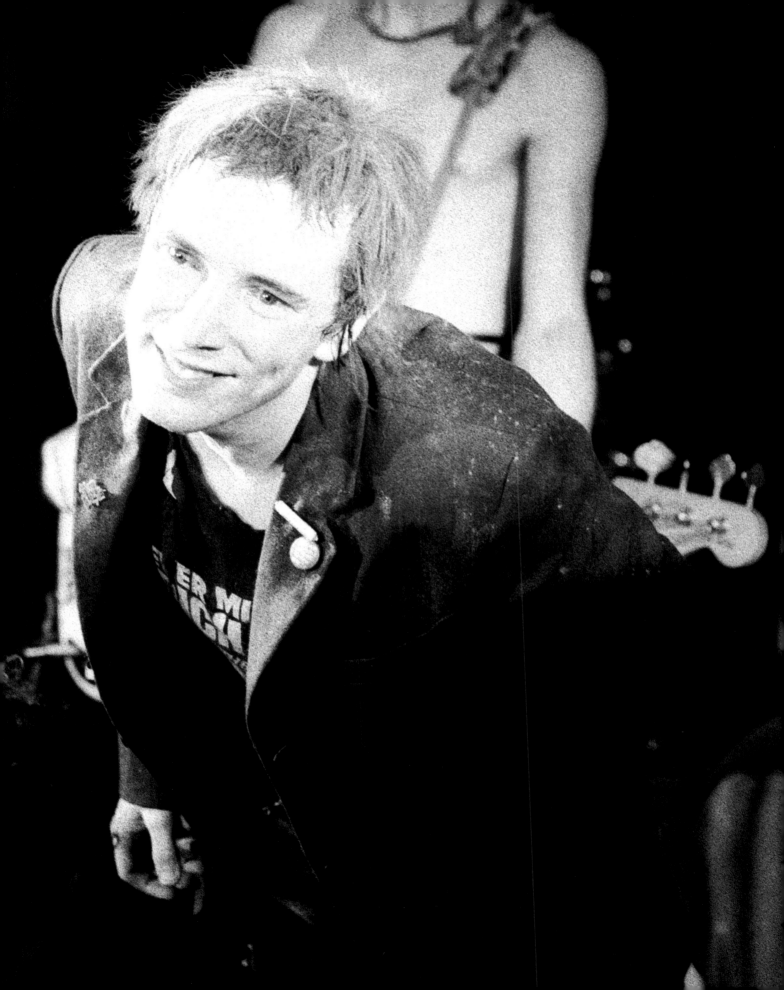

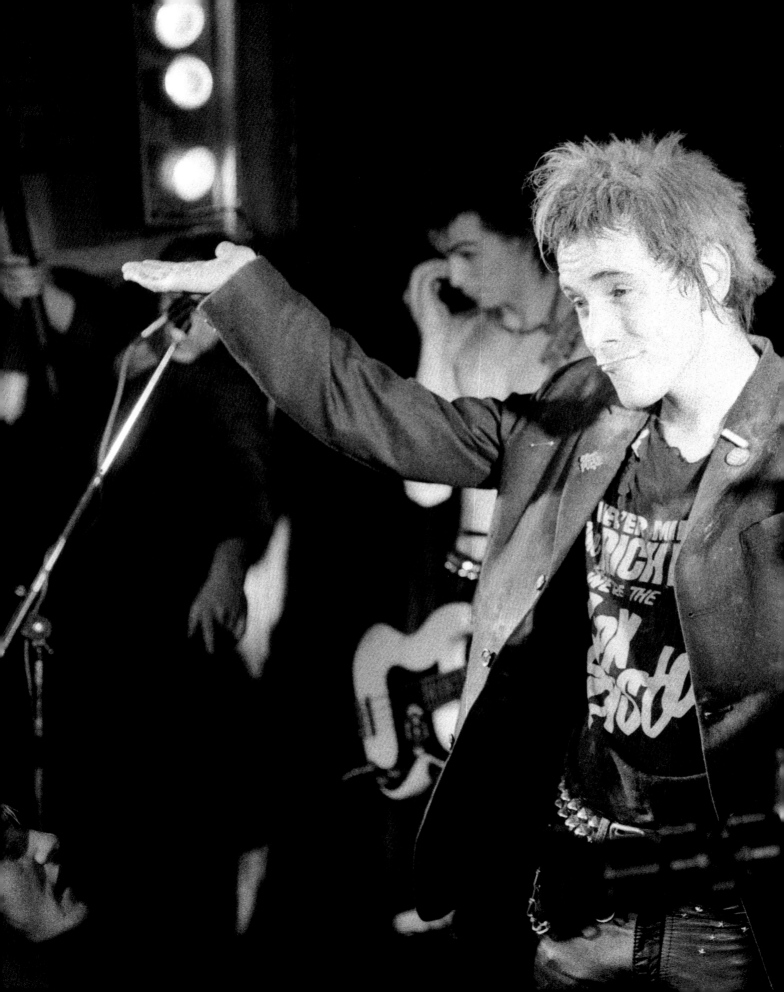

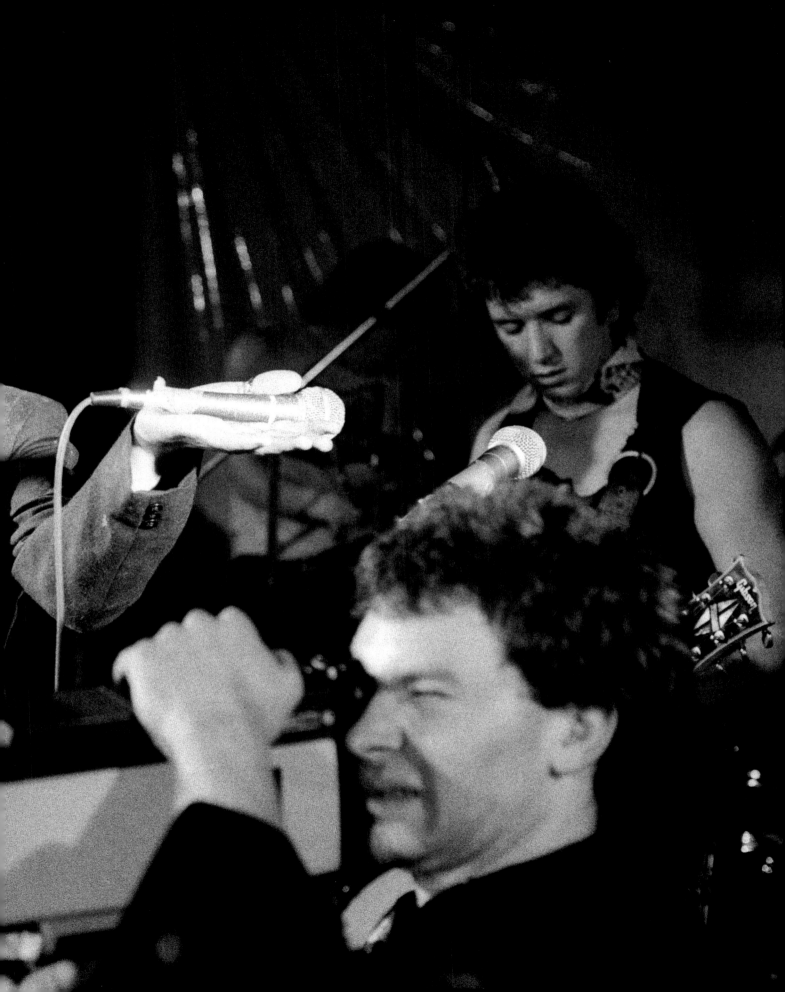

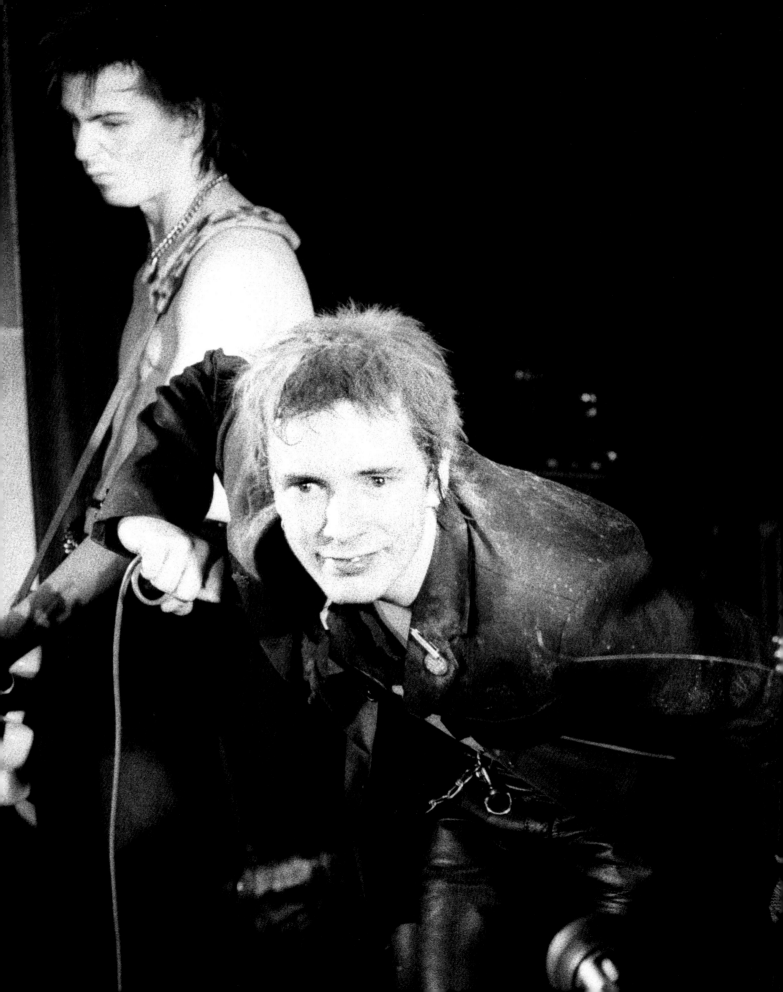

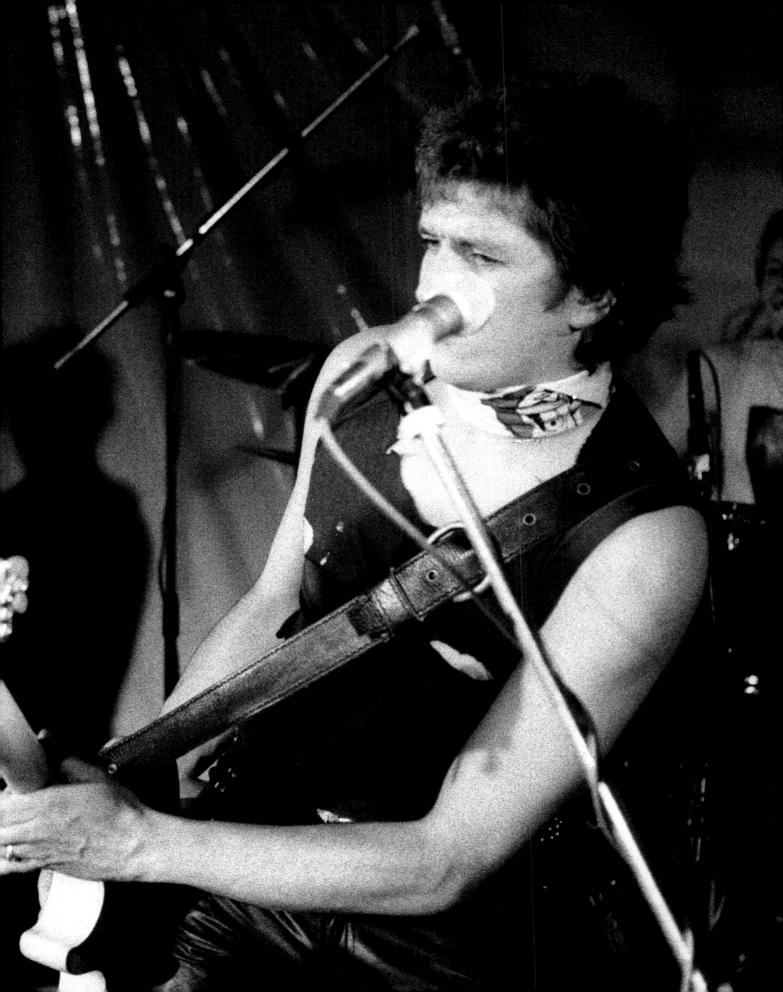

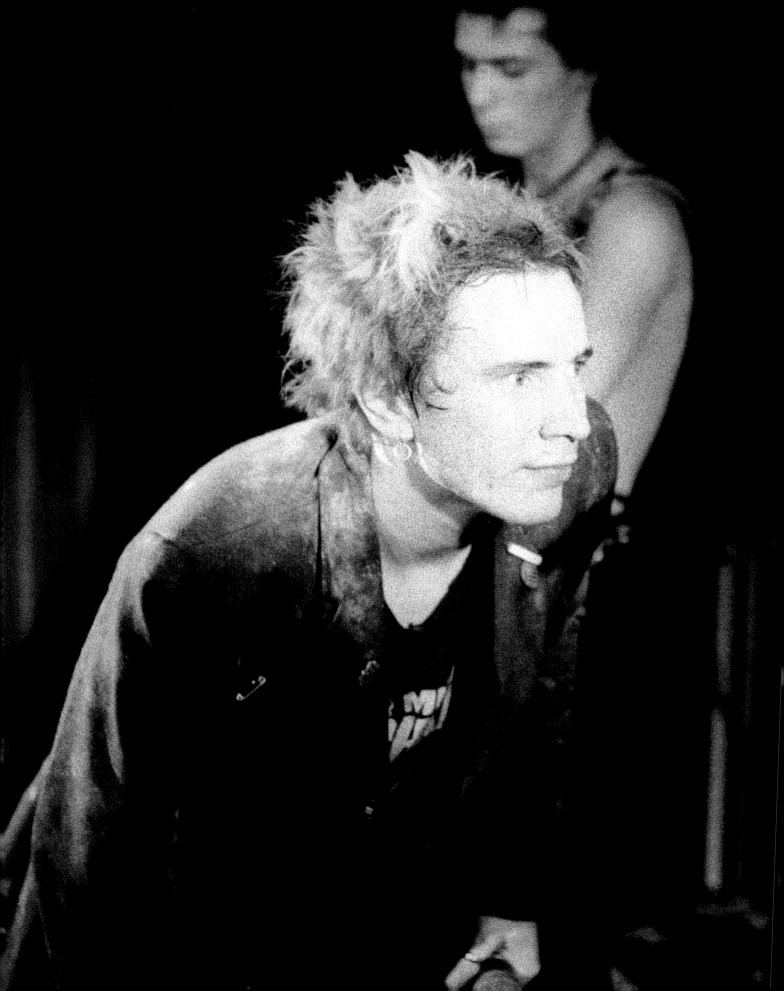

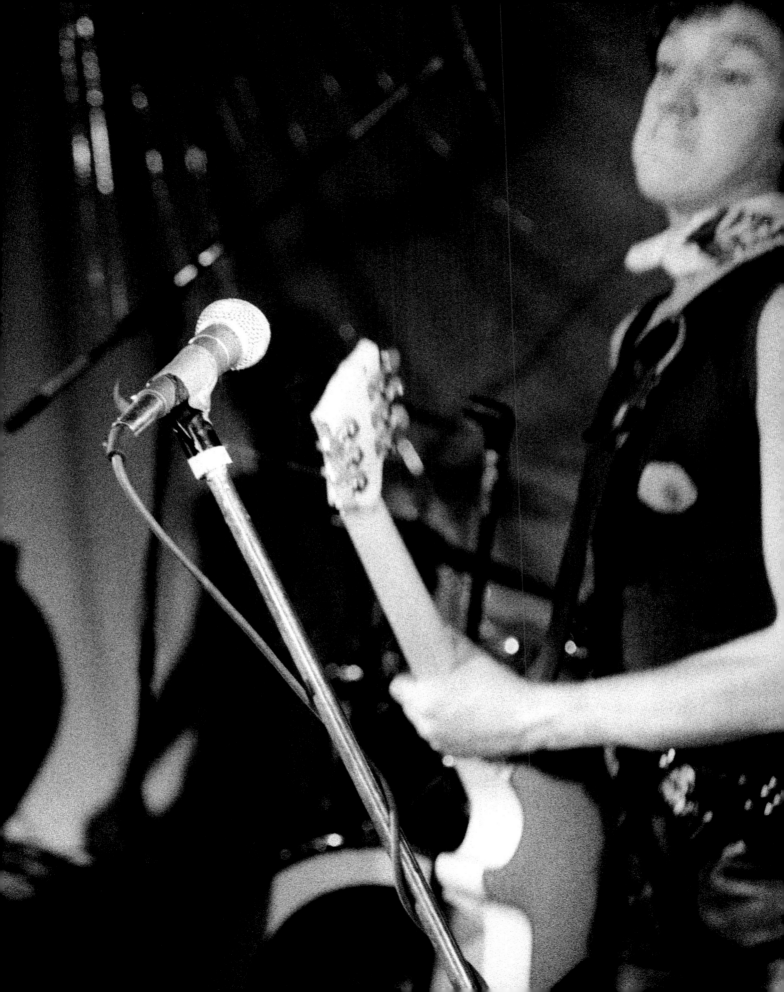

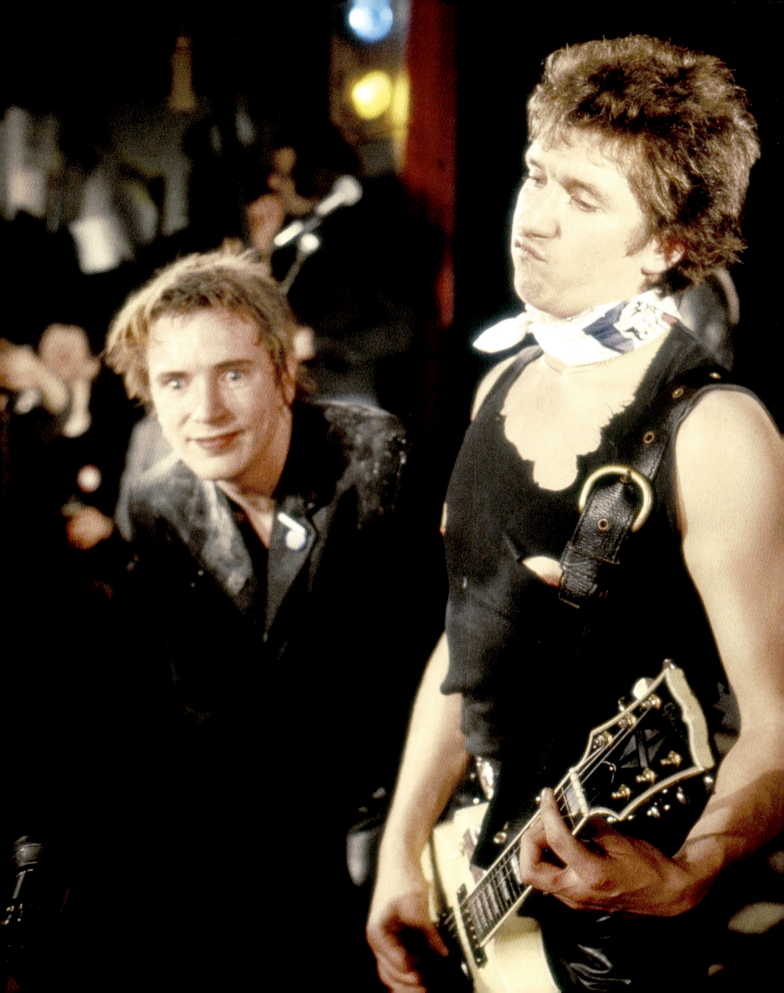

BEFORE HUDDERSFIELD
WE WERE STILL BANNED
AROUND MOST OF THE
COUNTRY… IT WAS JUST
GREAT THAT SOMEONE
ACTUALLY WANTED US
TO PLAY

PAUL COOK

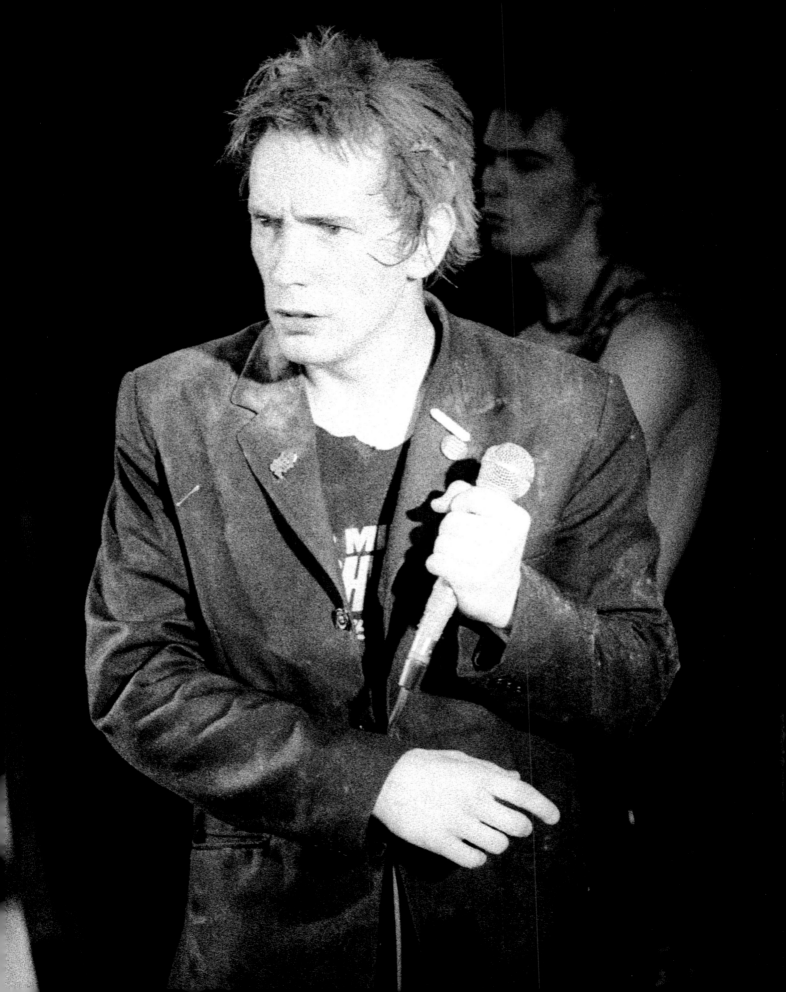

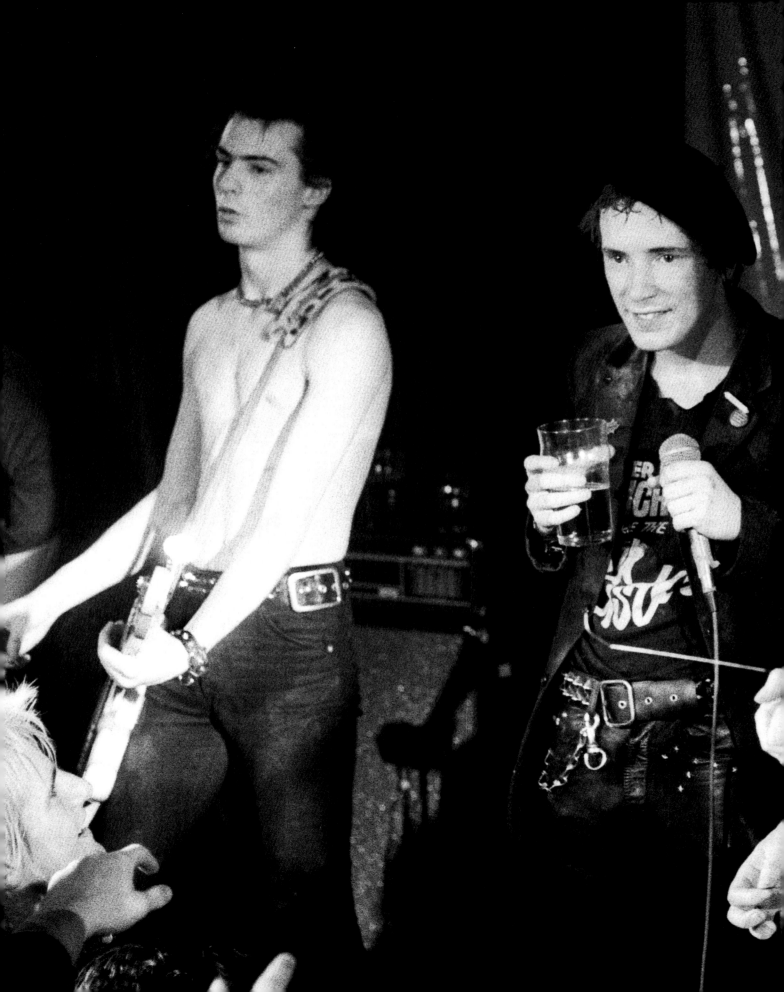

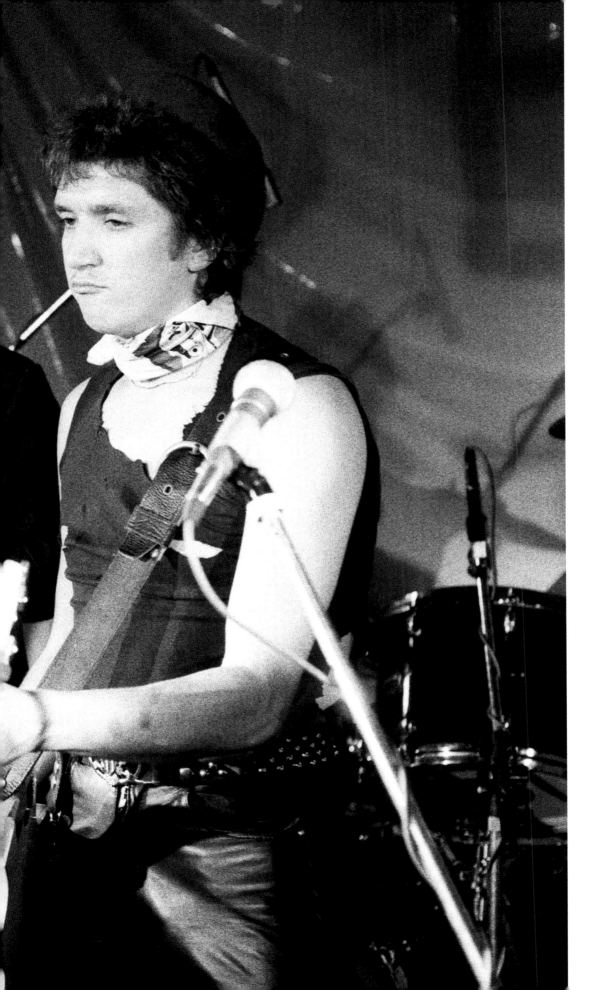

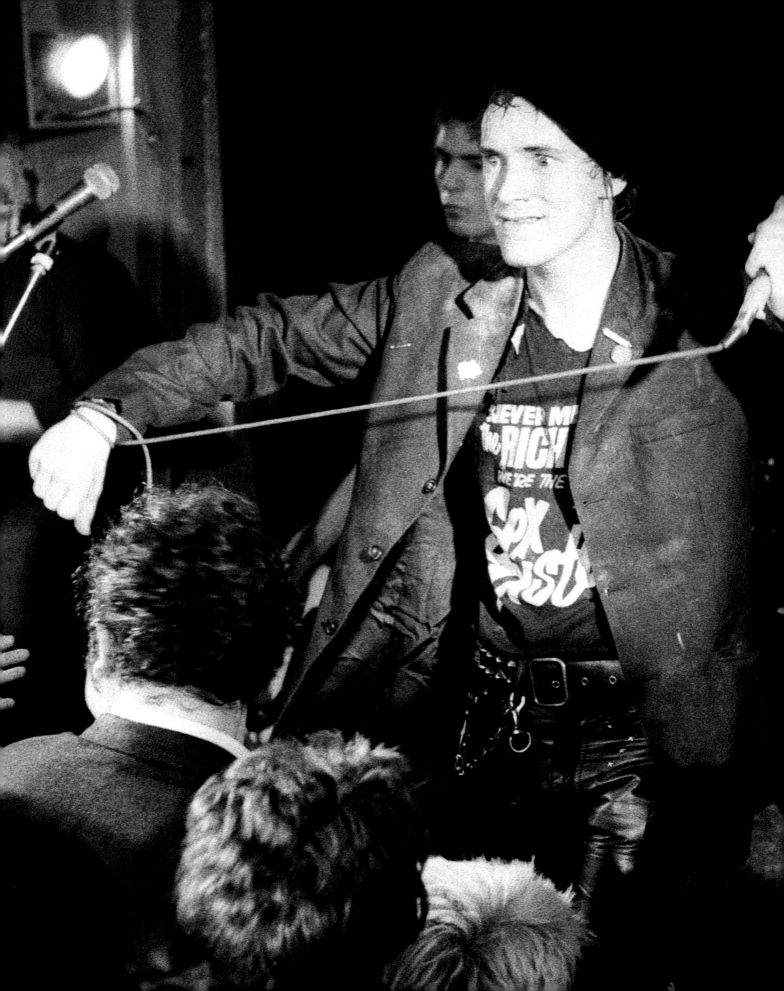

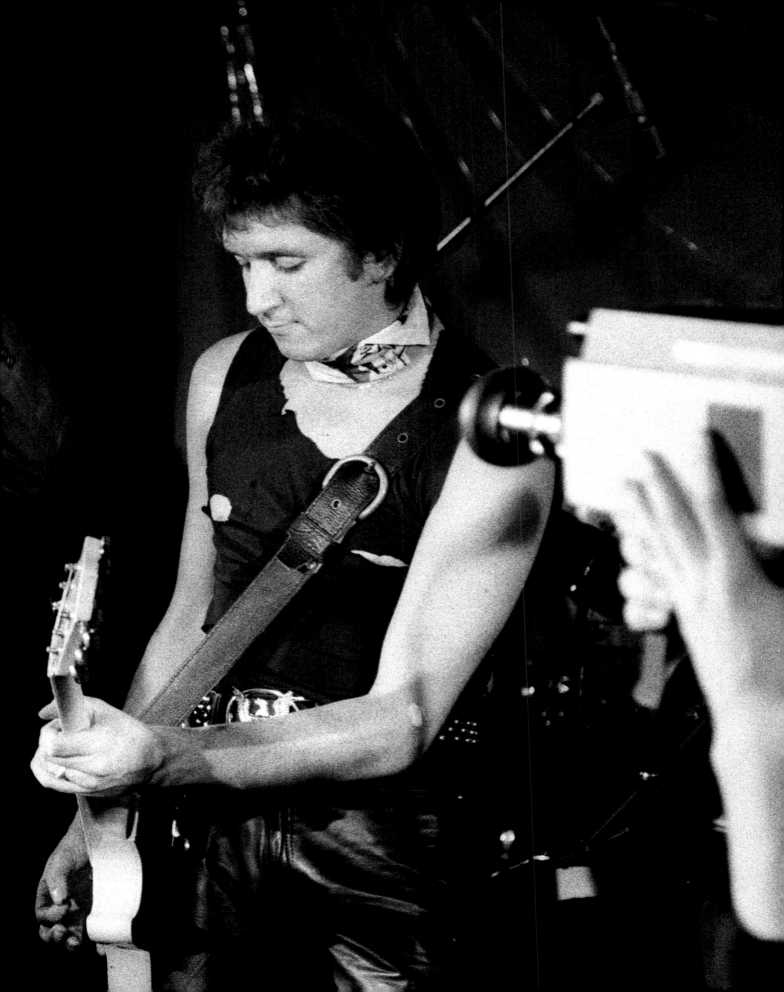

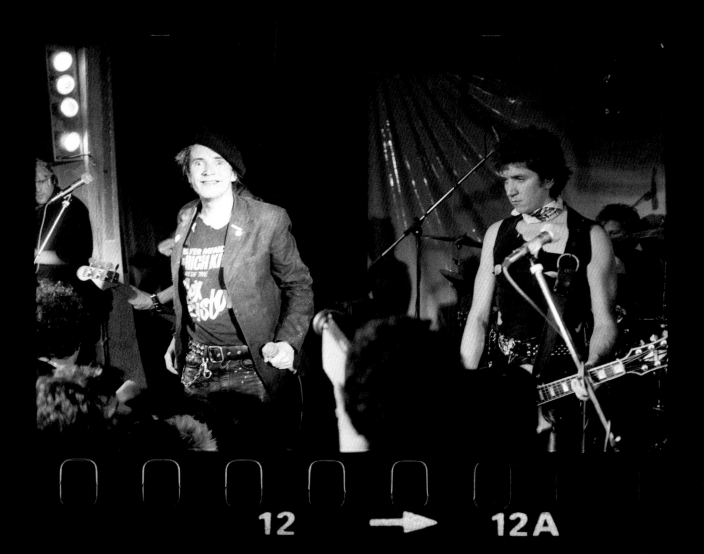

12 ➡ 12A

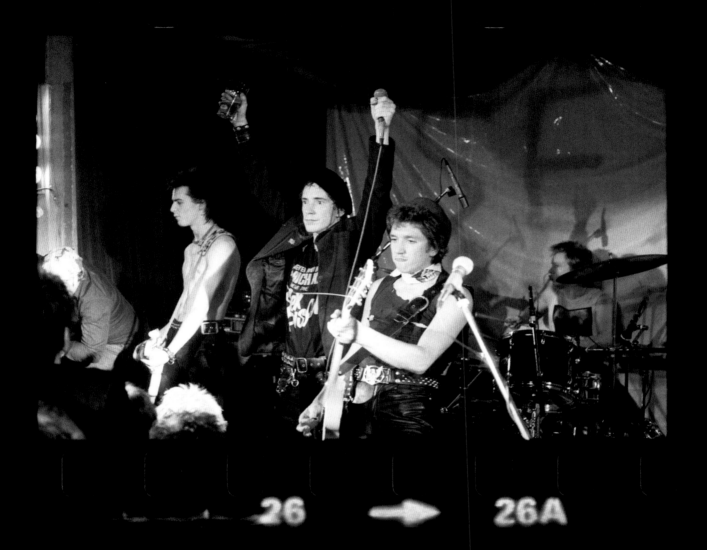

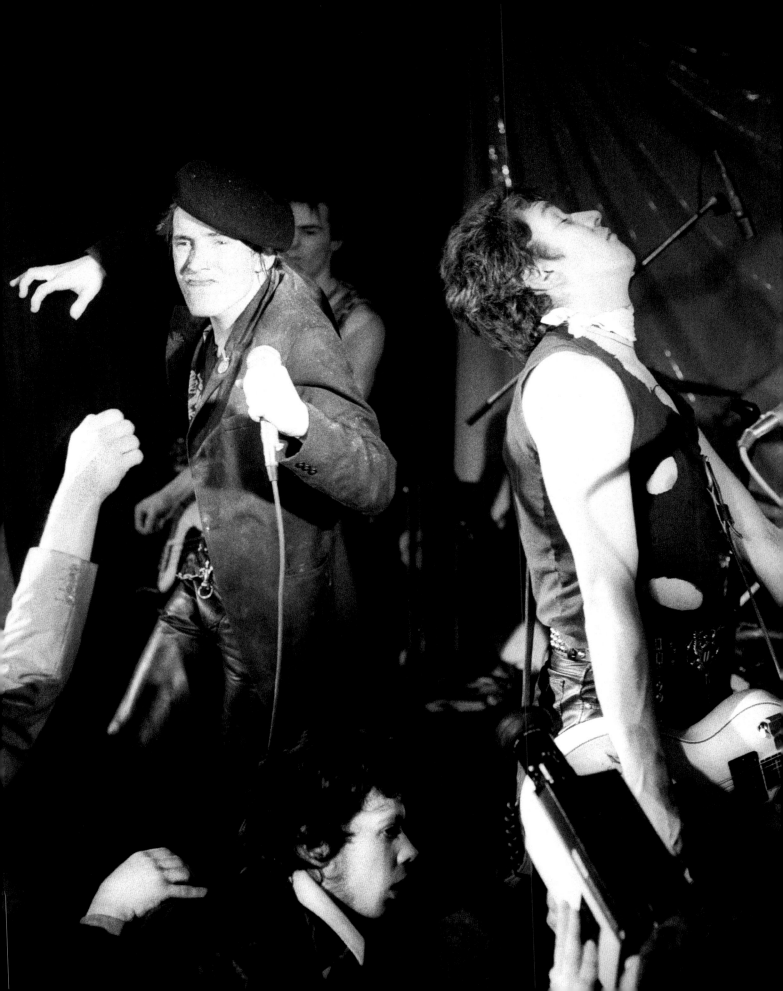

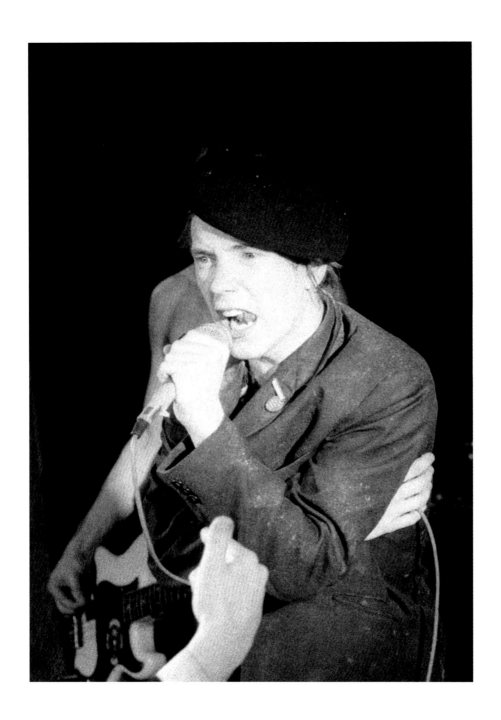

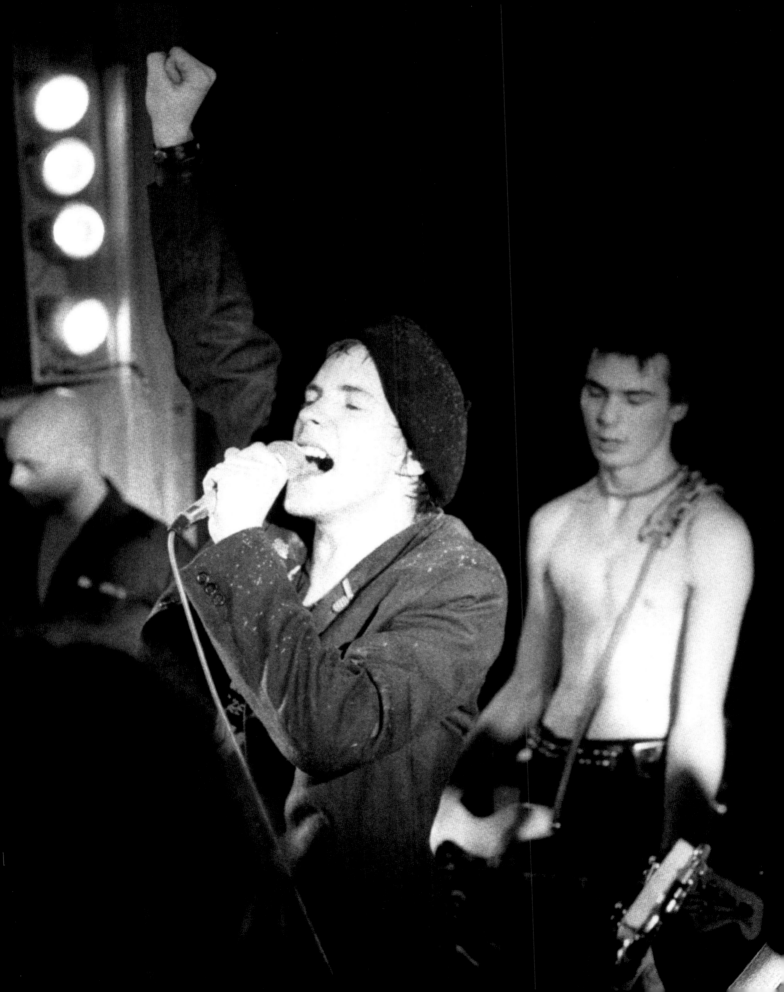

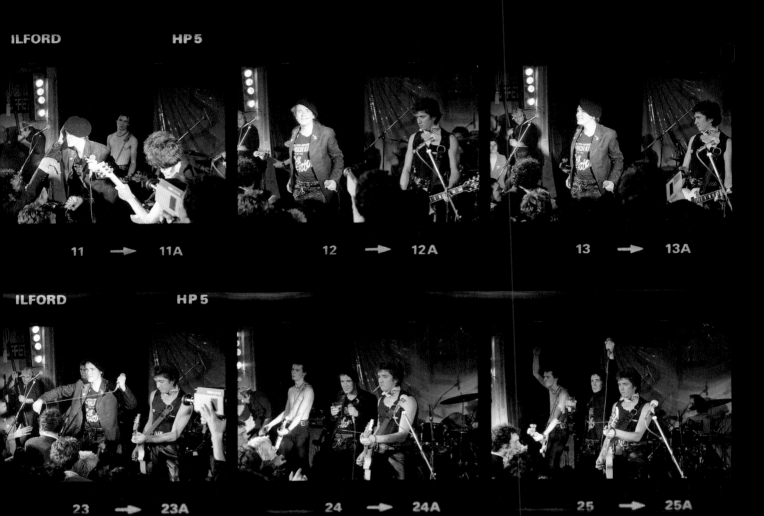

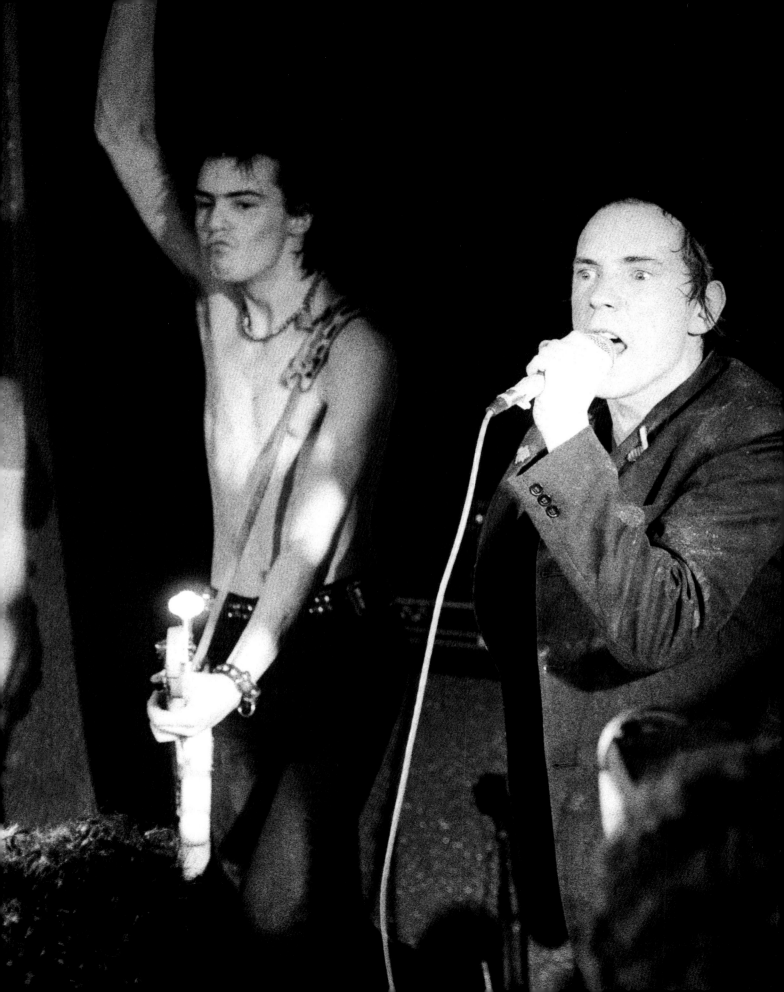

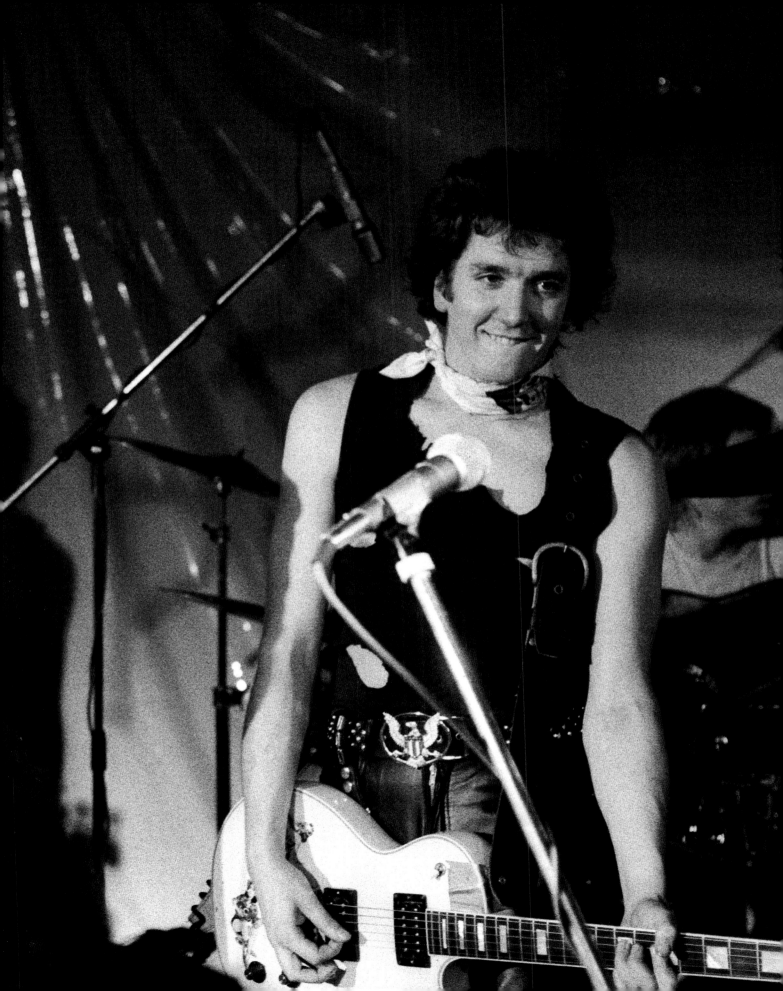

I THINK THIS IS PROBABLY
THE BEST CHRISTMAS
I'VE EVER HAD

STEVE JONES

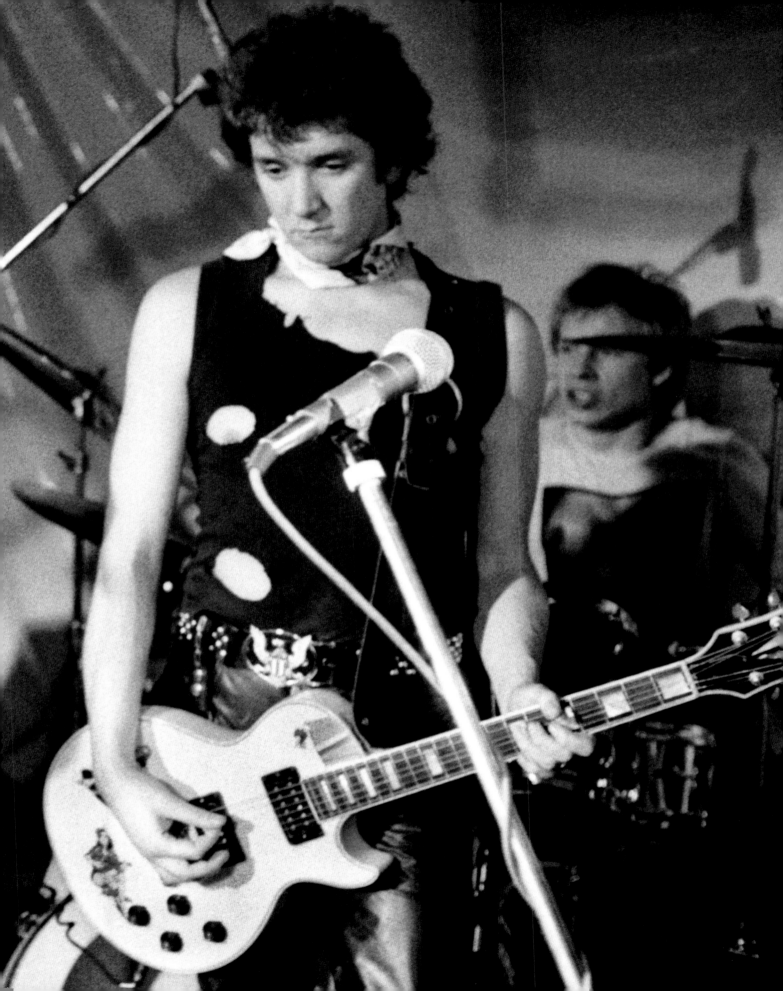

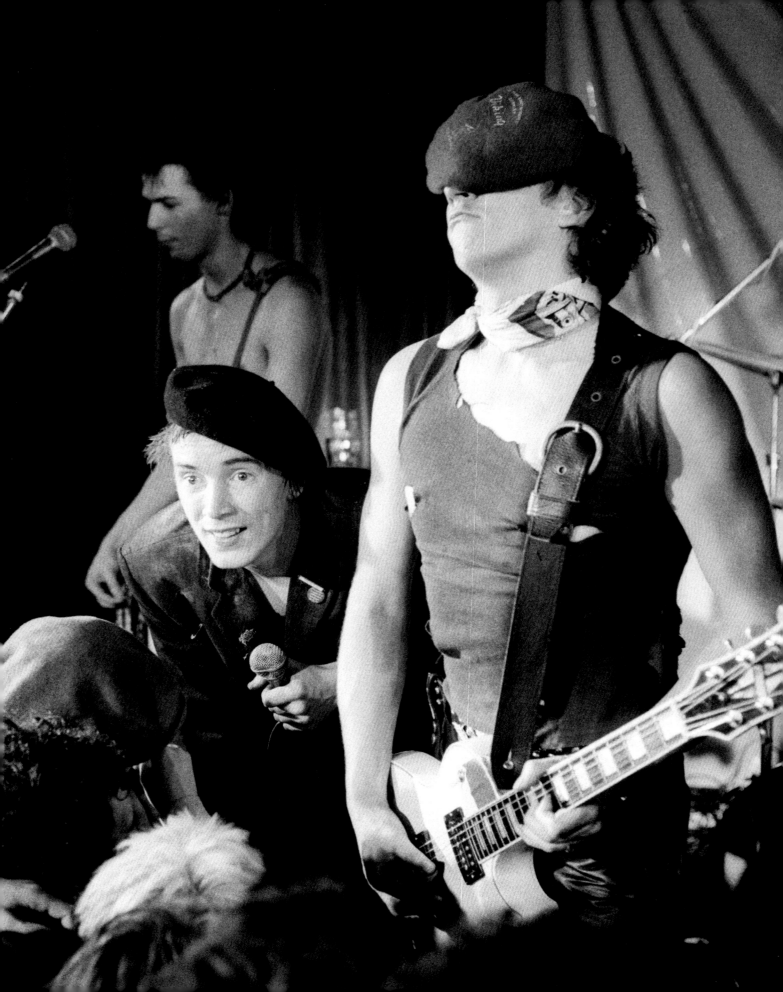

YOU CAN GATHER
WHAT IT WAS WE WERE
TRULY ABOUT BACK
THEN. IT WAS ALWAYS
FROM THE HEART
AND HUDDERSFIELD
SHOWS THAT I THINK,
REALLY WELL.

JOHNNY ROTTEN

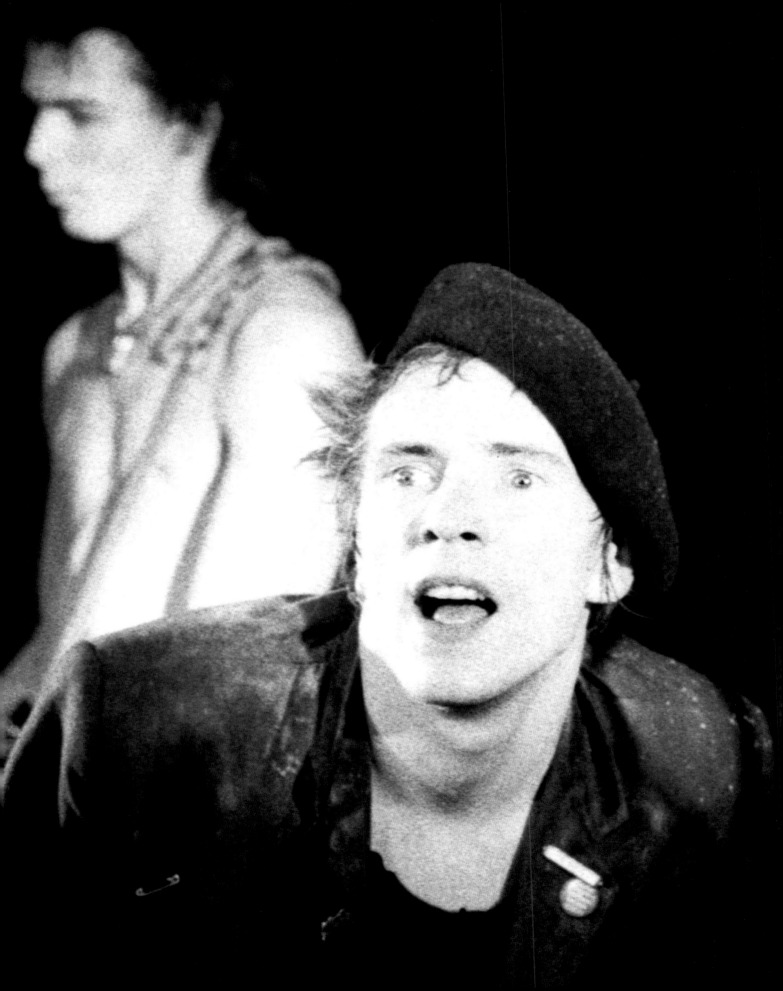

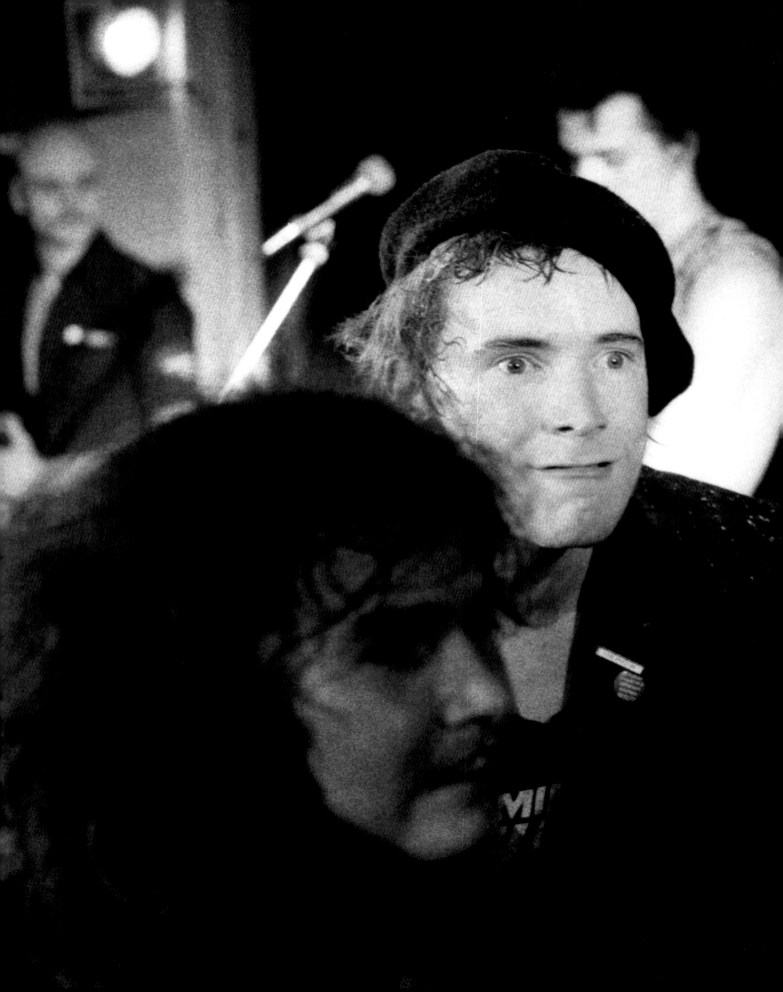

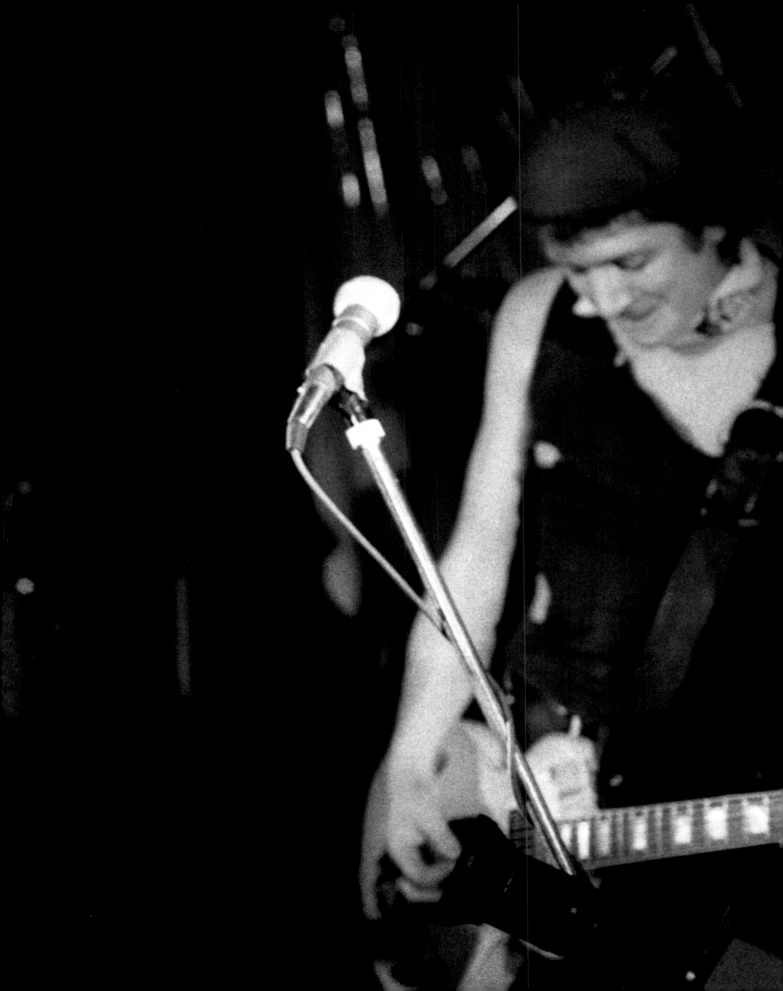

AS A BAND
THAT'S THE CLOSEST
WE'D EVER BEEN

JOHNNY ROTTEN

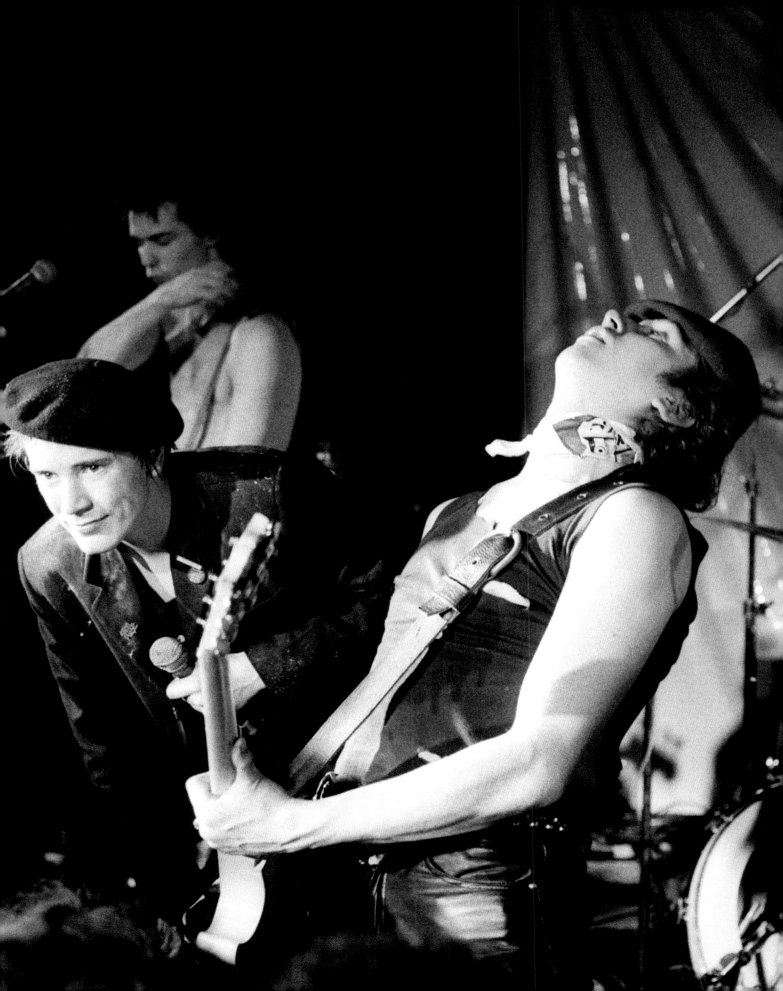

THIS WAS A GREAT WAY TO GO OUT

PAUL COOK

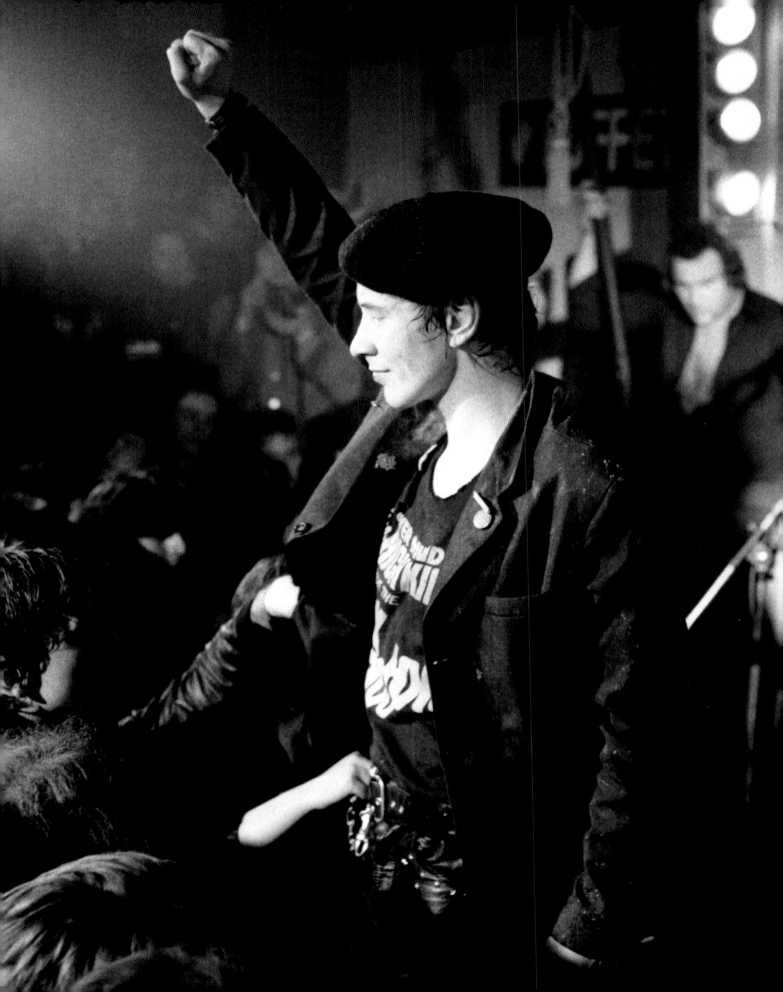

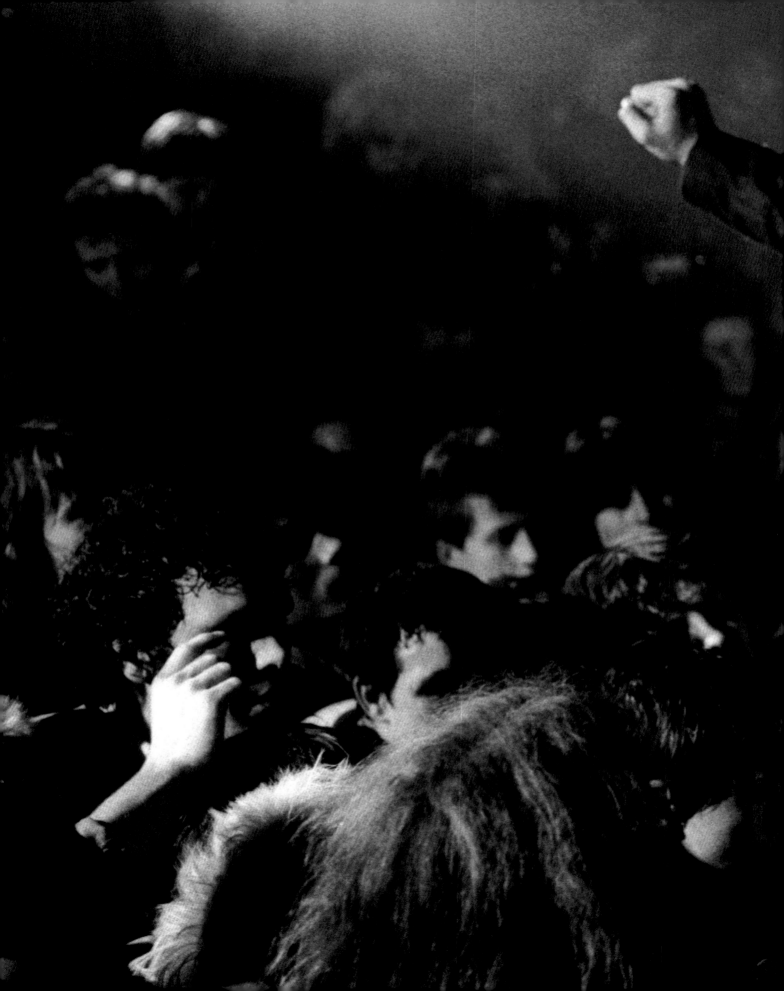

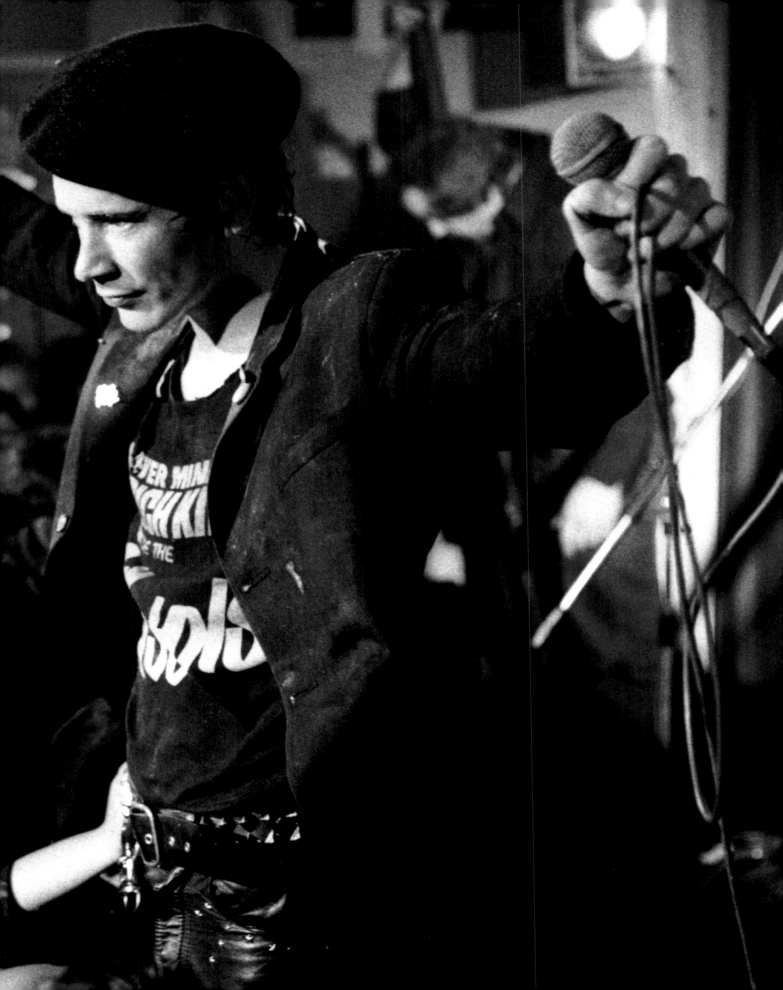

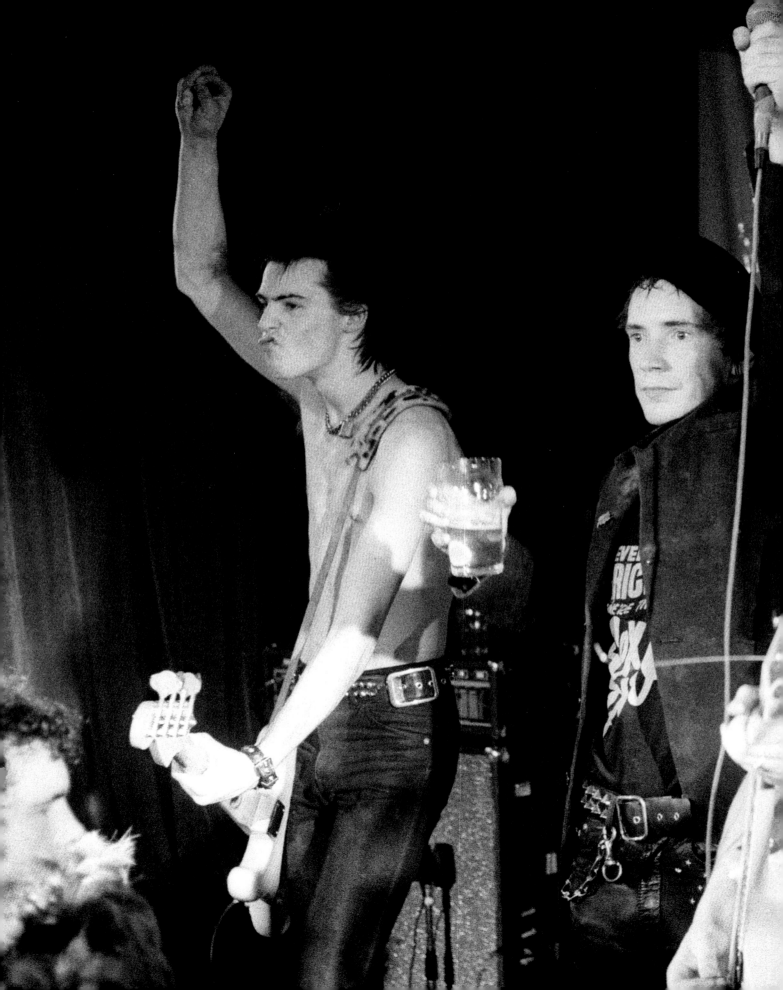

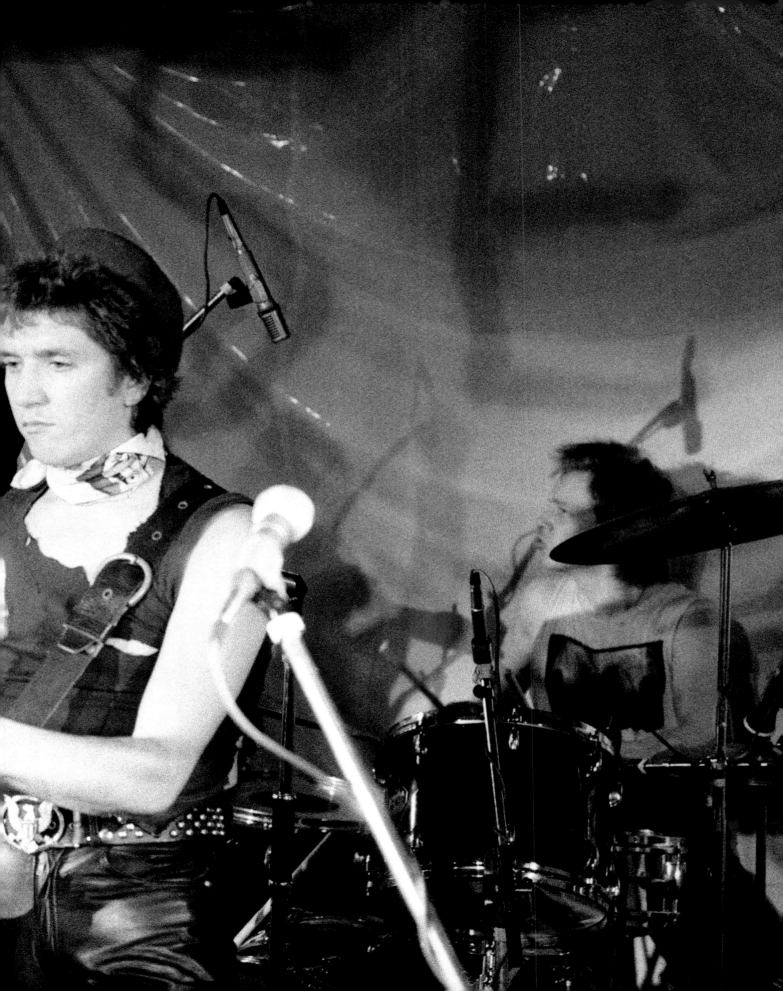

CODICIL

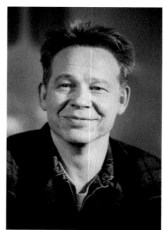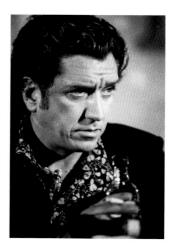

"At the press conference we gave at the 100 Club in March 1996, announcing our return,
they [the media] were lining up to hammer us.
It was a hostile atmosphere.
'Oh come on, isn't it all about the money?' they whine.
I don't want to run through my catalogue of answers, so I pre-empt them.
'I'm fat, forty and back. Deal with it. Next!'"

John Lydon

Thanks to: Earl Delaney and Paul Burgess for giving me access to their valuable archives. Gail Crowther for all her advice and support, and my agent, Carrie Kania for keeping everything on track (including me). Thanks also to everyone who worked on and contributed to this book. Your input was invaluable and I hope you're all as proud of it as I am.

Foreword text © Paul Morley

ISBN: 978 1 78884 061 3

British Library Cataloguing-in-Publication Data
A catalogue record for this book is available from the British Library

Designer: Mariona Vilarós
Production: Blake Lewis
Editor: Andrew Whittaker

Page 172: excerpt from *Anger is an Energy: My Life Uncensored,* John Lydon, Simon & Schuster UK, 2014.

Printed in Belgium
for ACC Art Books Ltd., Woodbridge, Suffolk, England

www.accartbooks.com

ACC
ART
BOOKS